P9-DMU-292

Perspective
Without Pain

Perspective
Without Pain

Phil Metzger

Cincinnati, Ohio

Perspective Without Pain. Copyright © 1992 by Phil Metzger. Printed and bound in Hong Kong. All rights reserved. No part of this book may be reproduced in any form or by any electronic or mechanical means including information storage and retrieval systems without permission in writing from the publisher, except by a reviewer, who may quote brief passages in a review. Published by North Light Books, an imprint of F&W Publications, Inc., 1507 Dana Avenue, Cincinnati, Ohio 45207; 1(800)289-0963. First edition.

96 95 94 93 92 5 4 3 2 1

Library of Congress Cataloging in Publication Data

Metzger, Philip W.
 Perspective without pain/Phil Metzger.—1st ed.
 p. cm.
 Includes index.
 ISBN 0-89134-446-2
 1. Perspective. 2. Drawing—Technique. I. Title.
NC750.M48 1992
742—dc20 91-43309
 CIP

Designed by Clare Finney

To Shirley Porter

Acknowledgments

When North Light asked me to consider writing a book on perspective, my greedy eyes lit up and I said, "SURE!" I figured perspective was a snap and I could knock it off in a few weeks. Months later and somewhat chastened, I realized that there was more to the subject than met the eye. There are thick books about perspective that dig deep into the mathematics and mystery of the subject. My job was to come up with a book that dispelled the mystery and concentrated on those aspects of perspective that someone in the "fine arts" would need to know. If you're an architect or an engineer, this book is not for you. But if you draw and paint as a hobby or for a living, I think you'll find it just about right.

I want to thank two people who participated in producing this book: Linda Sanders, my excellent editor at North Light, who kept steering me in the direction a book of this kind must take and really worked with me rather than sit back and accept whatever I threw her way; and Shirley Porter, who supplied a couple of the sketches in the book, but who mainly read my prose before I submitted it to Linda and savagely deleted most of the dumber things I had written. I honestly thank you both.

Perspective: the science of painting and drawing so that objects represented have apparent depth and distance. . . .
The Merriam-Webster Dictionary

Part One:
The Basics

Part One:
The Basics

If you're like most painters, you probably work hard at trying to make a flat surface appear to have depth. You look at the three-dimensional scene in front of you and sweat to get it down convincingly on your two-dimensional paper or canvas, but sometimes you're frustrated. A distant object doesn't look so distant on your paper, or an object seems the wrong size compared to another, or a building looks as though it's sliding off the page.

You're not alone. We all struggle throughout our careers to make our drawing more convincing. Some teachers say that our drawing problems are all magically solved once we learn to *see* better. If you see better, so the argument goes, you'll automatically draw better.

I think that's too simplistic. In order to draw well, four things are needed:

1. Seeing
2. Understanding
3. Practice
4. Technique

Seeing

Seeing means looking at the subject you're about to draw and analyzing it as a bunch of abstract shapes, colors, values and textures.

You must overcome what you "know" about the object. An editor at North Light Books who teaches figure drawing says that students drawing a model standing on a platform often have trouble drawing the platform correctly. They "know" the surface of the platform is a rectangle, and tend to draw it that way. The result is something like the drawing at **upper right**.

If they were to draw what they actually see, rather than what they know, they'd come up with something like the second sketch.

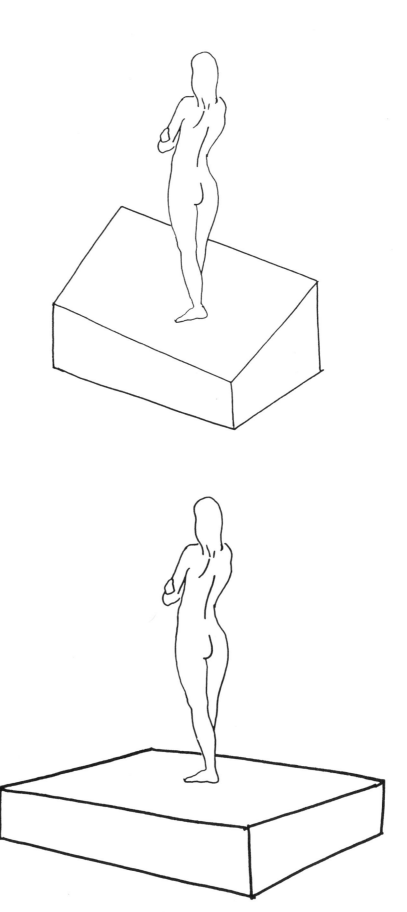

The Basics

Try to forget about what the thing really is. Instead of seeing a person standing on a platform, try to see first a combination of shapes. Don't concentrate on an arm with elbow outward and hand on hip, as at **bottom left**.

Instead, first try seeing shapes only, as shown at **bottom right**.

You'll find that as you get adjacent shapes right, the figure will gradually emerge. When the shapes are right relative to one another, add color, texture, shading, and so on. As you do so, these additions will force you to reconsider the shapes you came up with that you thought were so perfect. For example, when you get the "value" (the lightness or darkness) of the space between the arm and the body fairly correct, you may find that the shape of that space no longer seems right. Everything in a drawing affects everything else. So you fiddle with the shape, and play this back-and-forth game until you feel comfortable with the object you've drawn.

Understanding

Understanding means knowing what's really going on in an object you're trying to draw, even though from where you're standing the object doesn't look at all "correct." The model's platform is a good example. You know it is rectangular but all you can see is that crazy shape! You may wonder what good it does to know

what shape a thing really has if the idea is to draw it as you see it. Rembrandt had it about right when he said, "If you want to paint an apple you've got to be an apple!" If you want to paint something convincingly you've got to know it intimately. (That might be a little easier with an apple than with a live model!) Seeing accurately and abstractly gives you the ability to render a subject with mechanical exactness; understanding the subject enables you to give it soul.

Practice

Practice is what enables you to put your ability to see and understand to good use. It's the training you need to translate what you see and understand in your brain into shapes and colors and shades and textures on a piece of paper or a canvas. This book will offer you plenty of exercises for practicing the ideas discussed.

Technique

To practice anything you need to learn proven techniques developed by others and add your own as you gain experience. One set of drawing and painting techniques used by artists for centuries is called *perspective*.

Perspective is simply a set of techniques used to draw a three-dimensional scene on a two-dimensional surface. In other words, perspective is an approach

toward getting the illusion of depth in a drawing or painting. We'll play with several perspective techniques in this book. They are all simple once you get to know them, and they should all become part of the background knowledge every painter comes to use quite automatically.

To make the techniques easier to learn, I've arbitrarily divided them into the following categories, which we'll take one at a time:

- overlap
- size and space variation
- modeling
- detail and edges
- color and value change
- converging lines

This Book

There are three parts to this book. In this part I'll define and illustrate each perspective technique and offer exercises to help you practice using them. In the remaining two parts we'll dig deeper into how these techniques can be applied to real drawing and painting problems. As you'll soon see, it's rare that you'll use one technique and no others. They come into play in lots of combinations. Most of the illustrations and exercises will use more than one technique.

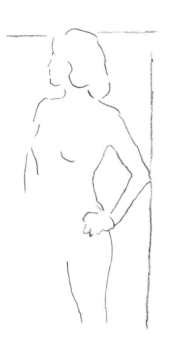

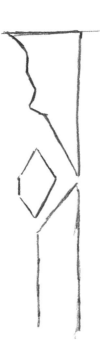

The Basics

The book follows a definite progression from basic to more complex materials, so it makes sense to study the book in order. Please don't skip any of the exercises. Some of them may seem too simple to bother with, but each one offers something to strengthen your ability to handle perspective convincingly.

Materials You'll Need

The things you'll need are inexpensive and simple. First, some pencils (2B-soft, HB-medium, and 2H-hard will suffice), or charcoal if you prefer; some tracing paper; occasionally a straightedge; a couple of colored pencils (or watercolor or pastels); scissors; some cardboard and a paper clasp; a flashlight; two pushpins; a piece of string about a half-foot long; a hand-held mirror; a piece of rigid plastic, such as Plexiglas; drawing paper; and a few other odds and ends that you probably have around the house. Most of the drawing paper you'll need is already supplied with the book.

The Picture Surface

Although you may actually be drawing or painting on a paper or canvas lying flat on a table or at a slant on an easel, always imagine that paper or canvas to be set up vertically between you and the things you're drawing or painting, and imagine that you're actually seeing through the paper or canvas and simply tracing on it.

That imaginary surface is called the *picture surface* or the *picture plane,* and I'll refer to it frequently throughout this book. When I speak of something as being "parallel to your picture surface," for example, I don't mean parallel to your actual paper or canvas, which may be held at any angle you find comfortable; I'm referring to the surface of the paper or canvas as it would appear if held up vertically between you and your subject, as shown **below**.

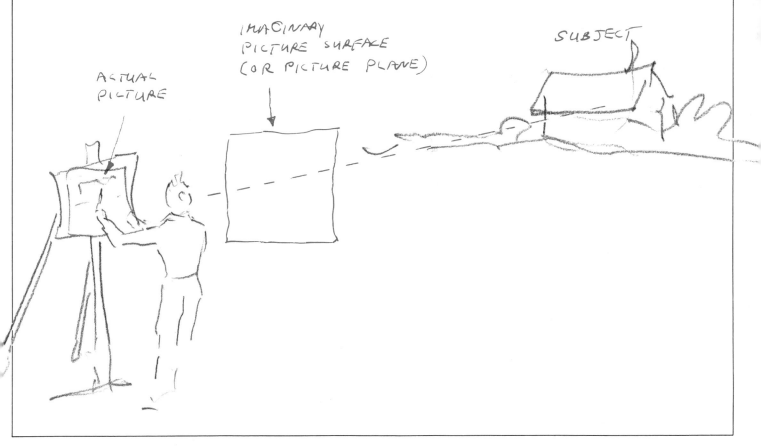

Overlap

The remainder of Part One discusses each of the six perspective techniques: overlap; size and space variation; modeling; detail and edges; color and value change; converging lines. Let's begin with overlap.

Suppose you had to bet your last dollar on which object in the sketch at **top right** is farthest forward. Could you win? There's really no way to know for sure without receiving a clue. The box and ball could be sitting side by side, or the box could be a building so far off in the distance that it looks nearly as small as the ball.

The clue can be provided by simply overlapping the two objects. In the second sketch I've put the ball in front of the box simply by hiding part of the box behind the ball. There's an immediate suggestion of depth where there was none before.

In the example **below** we have a similar situation. Is the tree a small one, closer to the viewer than the fence? Maybe, but on the other hand, this could be a large tree in the distance behind the fence. You can decide which object is to be more distant simply by overlapping one with the other. Using a piece of translucent tracing paper, roughly trace the outline of the tree and then shift the paper to the right so that the traced tree partly overlaps the fence. Make the tree appear to be in front of the fence by tracing only the portions of the fence that would be seen on either side of the tree. Then try the opposite: trace the fence first, shift the paper to the left, and draw the parts of the tree not blocked by the fence.

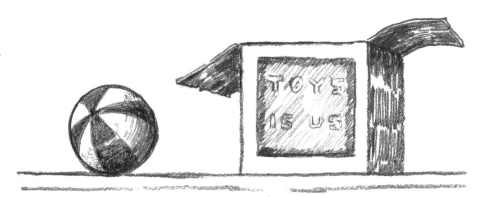

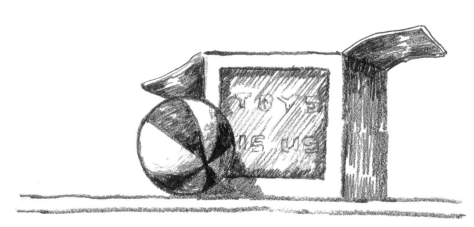

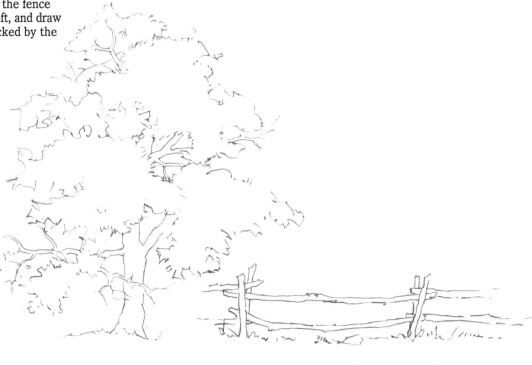

Overlap

Sometimes the overlapping you use might be less obvious. In the tree study **below**, the placing of branches in front of other branches is important. If no branches came forward or receded, the tree would be merely a silhouette with no depth at all.

By simply rearranging objects so that they overlap, all doubt about their relative positions is resolved and some added depth is introduced. While you can't actu-ally move some objects, such as the tree or the fence, you have perfect freedom to shift them in your painting. Why paint if you're a slave to what you see before you? Use the actual scene as a starting place and have fun adding, subtracting, and changing what's there. With the possible exception of a portrait, you're never obliged to paint anything literally.

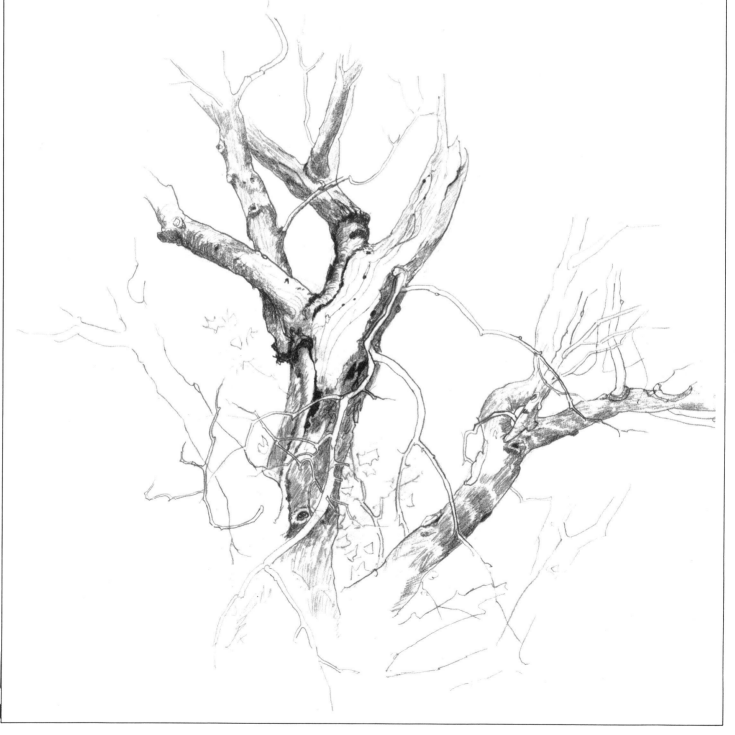

Exercise: **Overlap**

Here are four boxes lightly drawn in, with no clue as to which boxes are forward, which are behind. Use overlapping to make some boxes recede, others come forward. Start by tracing over all the lines of one particular box. Then trace in the lines of a second box, omitting any of its lines that fall behind the first box. Trace in the third and fourth boxes in a similar way.

Make a different box farthest forward in each picture. Notice that the box I have made smallest could actually be the largest if you simply make it the one far-thest away. How you place each box relative to the others tells the viewer a lot about the box sizes.

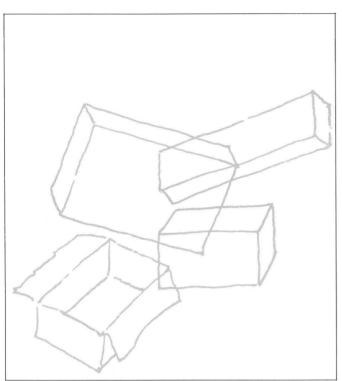
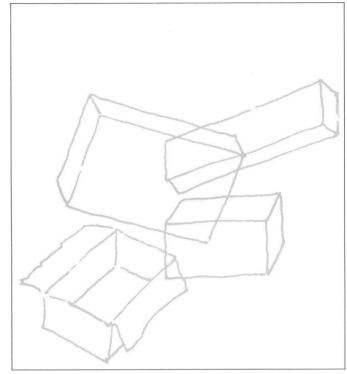
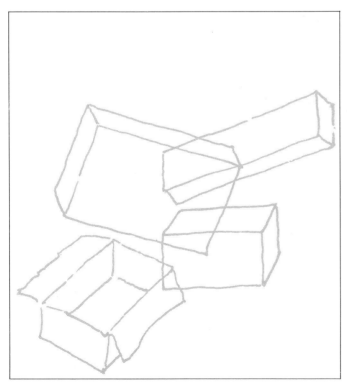
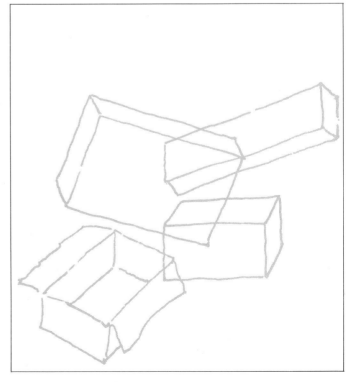

Size and Space Variation

Here are some fence posts marching across the landscape. The **top** row of posts does nothing to add depth to the picture.

But suppose we change the posts' relative sizes so that we have something like the **bottom** row. It's apparent that the leftmost post is closest to the viewer and the ones to the right are farther and farther away. This is the psychology of how we see things: if you know certain objects are normally the same size, but you see a picture in which those objects are *not* the same size, you'll automatically and unconsciously assume that some of those objects are farther away than others.

There's another difference between the two sketches. In the first the posts are roughly the same distance apart. That's how they're usually planted. But in the second sketch I've shown a constantly diminishing distance between posts as they recede. Again, that's how we see things. The sizes of all things, including the spaces between them, seem to diminish as their distances from the viewer increase.

At the **bottom** is another example of size and space variation.

You can try out size variation and spacing right on your desk or table or on the floor. Find a half-dozen or more objects that are about the same size: crayons, flashlight batteries, rolls of Life Savers—anything you can make stand on end. Stand them all up in a straight row,

all the same distance apart. Now get your chin down on the table or floor near one end of the row and squint down the row of objects. You'll see that the farthest one looks smaller than the nearest and you'll see that the equal spaces between the objects don't look equal.

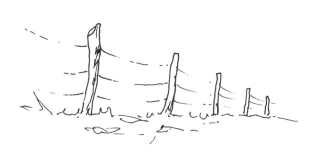

Louis Caravaglia, photographer; Lake Erie Ballet Company

7

Size and Space Variation

If you look down a railroad track you'll see that the wooden ties to which the steel tracks are fastened seem to get closer together as the track recedes from you. Other things diminish as well. The far end of the train station seems smaller than the near end; the tracks appear to squeeze together as they disappear into the distance; even the pieces of gravel between the ties are "larger" and more distinct in the foreground than in the distance.

Even though we may know that objects appear smaller as they recede, sometimes when we draw something like a row of poles or a fence going back into the distance, we're a little chicken about emphasizing the size differences between the nearest and farthest objects.

Take a peek ahead at the exercise on page 21. The fence post just to the left of the mailbox is nearly as high as the barn! Don't believe me? Measure it with a ruler. You'll see that the barn is not much higher than the post. As if that's not enough, the mailbox is actually bigger than the house! Yet both the posts and the mailbox feel right in the picture, don't they?

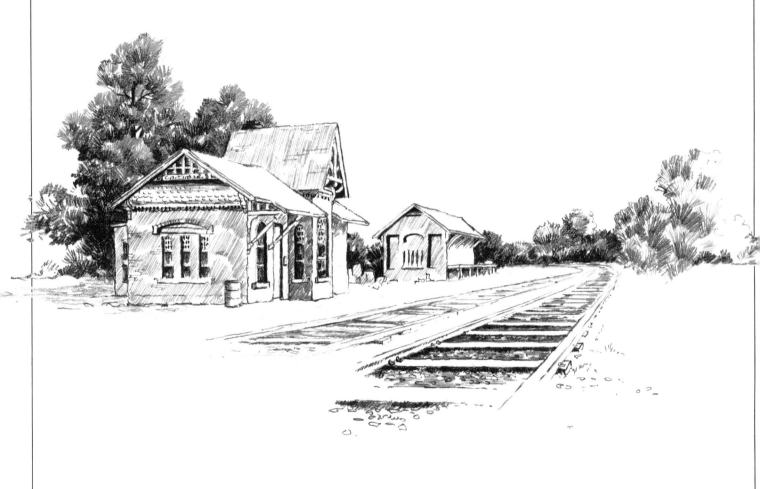

Size and Space Variation

Measuring

When you're in the field painting, or in your studio doing a still life or a portrait, you'll constantly be measuring things. You need to measure how big things are, how far apart they are, where their centers lie, how big one object is compared to another, and so on. You won't care about their *actual* sizes—what you need to know are *relative* sizes. The simplest (and handiest!) tool in the world for making such measurements is your thumb, along with a pencil or pen or a ruler or a stick.

Suppose you're looking at two objects, a brandy glass and a decanter, in a still life you're drawing. You know the decanter is about twice as tall as the glass, as shown at **top**, but the glass is in the foreground, closer to you than the decanter, so in your drawing the glass will not be half the height of the decanter but something more than half as high. How much more? You don't need to know in inches or centimeters. All you need to know is their relative heights.

Standing at your easel, hold up vertically at arm's length any straightedge, such as a pencil. Close one eye (only one, please!) and sight along the tip of the pencil to align it with the top of the glass. Then slide your thumb along the pencil shaft to where it marks the bottom of the glass, **below right**.

Okay, that's how high the glass is. Now, without moving your thumb from its position on the pencil, align the thumb-mark with the bottom of the decanter. Now look at where the pencil tip falls and make a judgment: how much higher does the decanter appear than the glass? Certainly not twice as high, which you know to be the case. No, it appears to be less than twice as high. Make a mental calculation. Perhaps the decanter seems one-and-a-half times the height of the glass. Try that out lightly on your drawing and see if it feels right. If the glass in your drawing is four inches high, make the decanter six inches high. If it doesn't feel quite right, try again.

You may feel a little uneasy about "measuring" without coming out with an answer in inches or feet. An old fellow I worked with as a boy used to measure the width of foundation holes we were digging in such terms as, "It's about six pickaxe handles and a hammer!" If such estimating troubles you at first, try using a ruler instead of a pencil. Use it in the same manner as the pencil and note where your thumb rests after marking the height of the glass. Let's say it's at the three-inch mark on the ruler. Now do the same for the decanter. If your thumb rests at the four-and-a-half-inch mark, that means that indeed the decanter you draw should be about half again as high as the glass. Of course, your drawing can be any size (maybe a two-foot high glass and a three-foot high decanter). What matters is proportion—that is, the relative heights of things.

What's the payoff for getting proportions right? Your reward is a convincing illusion of depth—and that, after all, is what this book is all about. Spend a few minutes with just your pencil as a measurer and do some relative measurements on the things you see around you. You'll be surprised at how "big" some smallish items can seem just because they're closer to you than some items you know are larger. I'm sitting here and measuring some of the things in my office and here's what I discover. My left foot is about half as long as the height of my five-drawer file cabinet. Come on, now! My feet are big, but . . . ! And the window at the end of the room is exactly as high as my pencil. The coffee mug at my side is bigger than the waste basket over against the wall. That's a lot of coffee!

As you go through your day, notice the relative sizes of things around you. There's always a pencil or pen handy. Hold one up when you're stopped at a traffic light. Compare the relative sizes of cars, people, buildings, poles. Don't worry about the light. The creep behind you will lean on the horn to tell you to get moving the instant the light turns green.

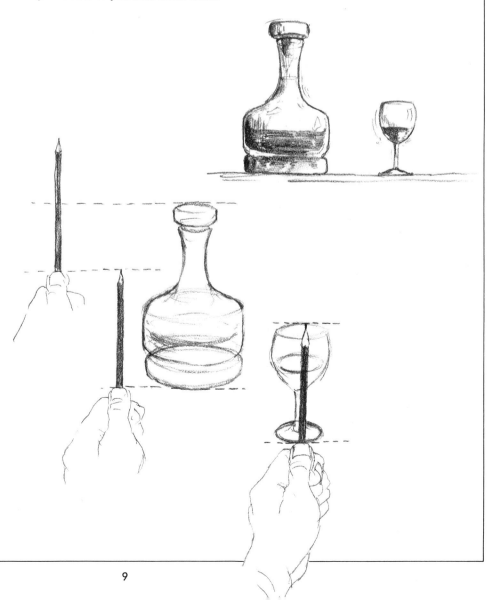

Exercise: **Size and Space Variation**

Complete each of the three drawings in this exercise in such a way that you show depth by gradually diminishing the sizes of, and the distances between, similar objects as they go into the distance. Sometimes it's helpful to draw light guidelines as I've done for you in the warehouse example so that you can "fit" all the objects (such as a long row of windows) between the lines. Use this device sparingly, though, so that you don't make your drawing too rigid. In the warehouse example, it's quite likely the windows *will* be all the same size, but in the next example, it's not likely the police officers will all be the same height. Don't worry about making perfect cops or windows or pickets; the important thing is to understand the usefulness of size variation and space variation in achieving the illusion of depth.

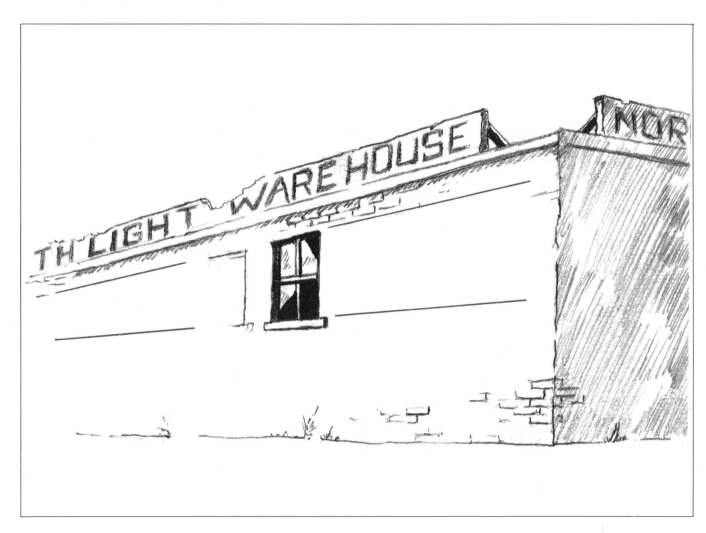

Exercise: **Size and Space Variation**

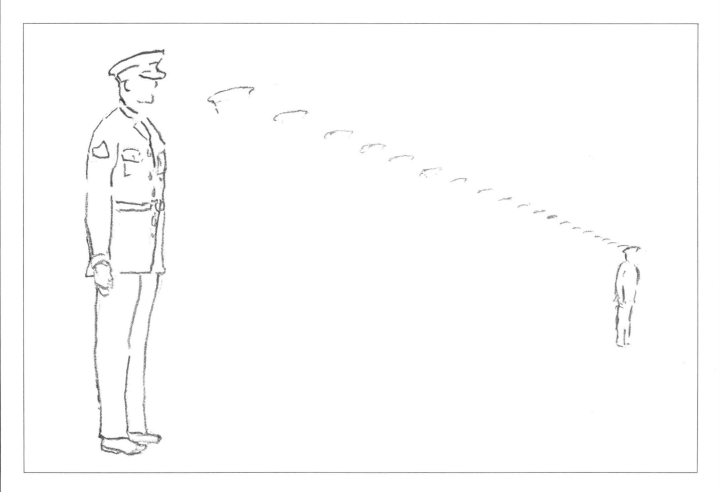

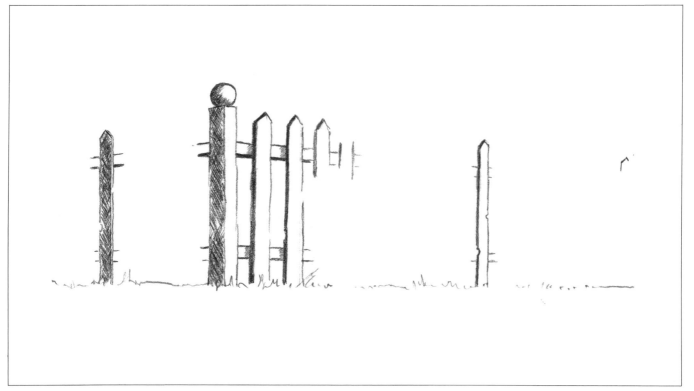

Modeling

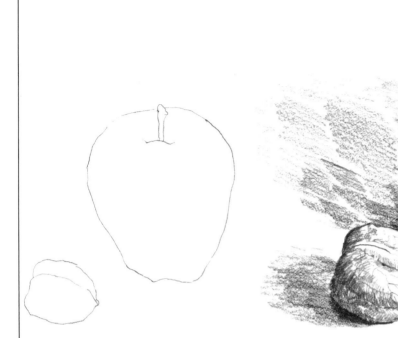

Look at the example **above left**. What the heck are these things? A pretty flat walnut and an even flatter apple. Now see what a little modeling, or shaping, can do, **above right**.

Although we give a lot of space in this book to the idea of getting literally miles of depth (treelines stretching away to forever, mountain ranges going back as far as the eye can see), not all depth is measured in miles. Sometimes you're concerned about inches. That's when modeling comes into play.

What I mean by modeling in this context is giving form to an object. Partly this is accomplished by line work, but what I'm interested in here is the use of shadow. Whether you're painting an apple, a silo, a pole, or even a square box, modeling is necessary to indicate form and give the picture life. There are a couple of basics to pay attention to when you're modeling an object:

1. Determine exactly where the light source is to be. If you're painting a real scene, the sun, or some artificial light such as a lamp, is your source and there's no problem remembering where the light is coming from. But if you're imagining a scene, or if you're arbitrarily changing the position of the light source, you need to note where it's to be located and then model the objects in your picture accordingly. Don't start off with the sun shining from the upper right and then halfway through the picture forget where it was supposed to be and start modeling and painting shadows in the wrong directions. I often draw a little circle representing the light source at the upper right or upper left of my painting in case I get distracted and forget what I was doing. I also add a little three-dimensional arrow to remind me whether the light source is behind me or in front of me.

2. Observe carefully just how the object is modeled. As the rounded form of the apple, for example, turns away from the light, you might expect the edge away from the light to be consistently the darkest part of the apple.

But that's not always so. There are probably other sources of light in the room, or light from your single source may be reflected from other things, such as a tablecloth or other nearby object. That reflected light can reach the shadowed part of the apple and make it appear lighter than you expected. In fact, there can be so much reflected light or light from other sources that you see complex variations in a shadow you thought would look pretty uniformly dark.

You can experiment with such light shenanigans by setting up a few objects in a darkened room with a single lamp as a light source. Move things around and observe the effects of light reflected into shadow areas. If you get a chance to observe two silos (or any two large, shiny objects) side by side in strong sunlight, look carefully into the shadowed side of one and find there some reflected light from the other. One thing has become clear to me after years of painting shadows: the more intently you look at an area of shadow, the more varied and interesting you'll find it. Shadows are not dead; they're very much alive.

To get more practice in the use of shadows, find an apple, set it on a white surface, darken the room, and spotlight the apple with a single lamp. Then make a number of charcoal sketches trying to record the subtle gradations of shadow that give the apple form. Move the lamp to different positions and sketch again. Then place a white cup alongside the apple and sketch again, noting how the reflections from the cup affect the shadows on the apple.

Detail and Edges

Suppose you're taking a photograph of your grandmother making her debut as a wrestler. It's her big night and you want to get it right, so you aim your camera at her as she's being introduced in the middle of the ring, carefully focus on her, and release the shutter. When the picture is developed, what you see is Granny, crisp and clear, along with the referee. It's easy to make out the details of the area you focused on—Granny's missing front tooth, her gnarled muscles, her baggy shorts, the pink ribbon in her hair—but the rest of the picture is less distinct. You can make out the crowd in the distance, impatiently waiting for some blood, but the forms are more and more fuzzy the farther they are behind Granny. You can barely make out the shadowy shapes at the rear of the arena.

Your eyes work the same way. They can focus on objects at one distance away; they cannot focus on objects near and far at the same time. Look intently at some object in the room right now, say, your thumb at arm's length. While keeping your eyes focused on your thumb, notice how everything else in the room is out of focus and how little detail or texture you can make out on objects farther and farther from your thumb.

You can give your drawing or painting more depth by treating a scene the way the camera or the eye would see it: pick a distance you want to be most in focus and then make all objects beyond that distance gradually less distinct. You can help accomplish this by (1) blurring the edges of more distant objects, and (2) showing less detail in the distant objects.

At **right** are two versions of the same subject. In the first, I've made everything pretty much in focus, both the still life and the busy wallpaper behind it. In the next sketch there is greater depth because I've pictured things more as the eye or the camera would normally see them, focusing on the closer objects and letting the distance become fuzzy and less detailed. Not only does the picture gain some depth, but it becomes less busy as well.

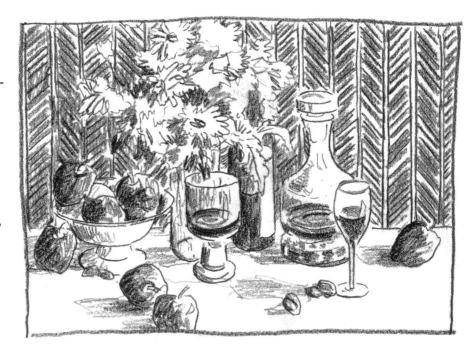

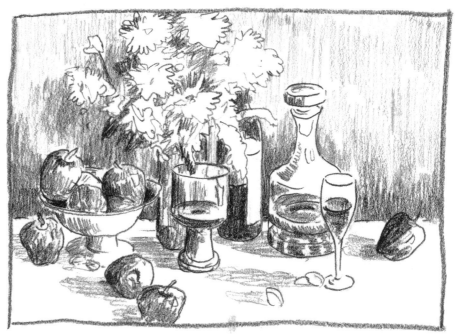

Detail and Edges

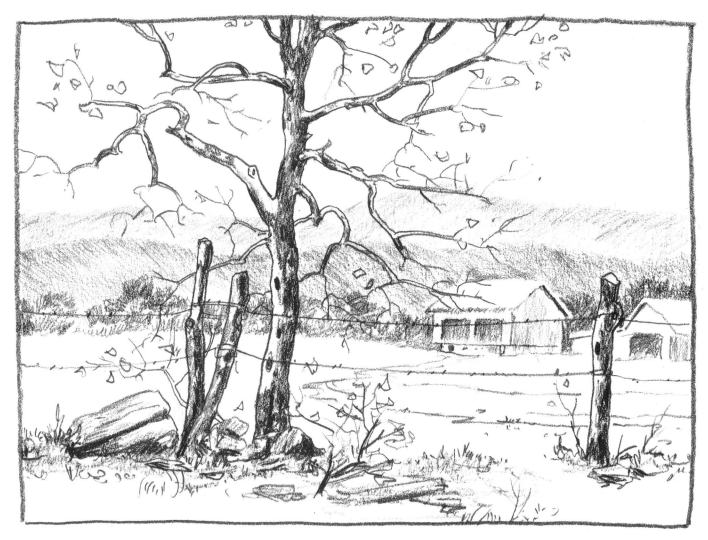

In this sketch the focus is again on nearer objects. The edges of the more distant things are blurred and their detail minimized.

So the lesson is simple: To help get depth in your picture, paint things as you see them, using harder edges and more detail for one distance while letting other distances become gradually less in focus and less detailed.

There's a related consideration, not having too much to do with gaining depth, but having plenty to do with effective painting. Painters often feel compelled to make the foreground of a paint- ing very detailed, even though the foreground is not the center of interest. There is no rationale for doing this; if you were at the scene focusing on the middle distance, the grass at your feet would be only a blur. When you shot Granny in the ring, the people between you and Granny came out blurred in the photograph, didn't they? If, on the other hand, the foreground is to *be* your center of inter- est, then by all means go ahead and draw in all those little grasses or whatever, but be sure to make everything else less dis- tinct.

Exercise: **Detail and Edges**

Carefully render the drawing on the next page, using either pencil or charcoal. Make the boat the center of interest and subordinate everything else to it. Blur edges and show less detail in areas farther from the boat.

You can either start with the lightest shading in the far distance and work up to the strong edges and details in the boat, or vice versa. It's a good idea to establish a range of lights and darks right off the bat, so that you know where you're going to place the lightest, most blurred areas, and where you're going to put the darker, more crisp areas. Once you've established your range, you can fit everything else in between those extremes.

The little thumbnail sketch will give you a start. Notice I've indicated the direction of the sunlight. Change the direction if you wish, but use your light and shadow consistently. In modeling a clump of trees or shrubs, for instance, make the undersides and the sides away from the light source generally darker than the sunlit sides.

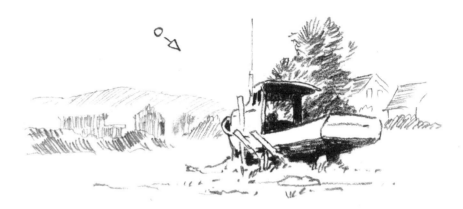

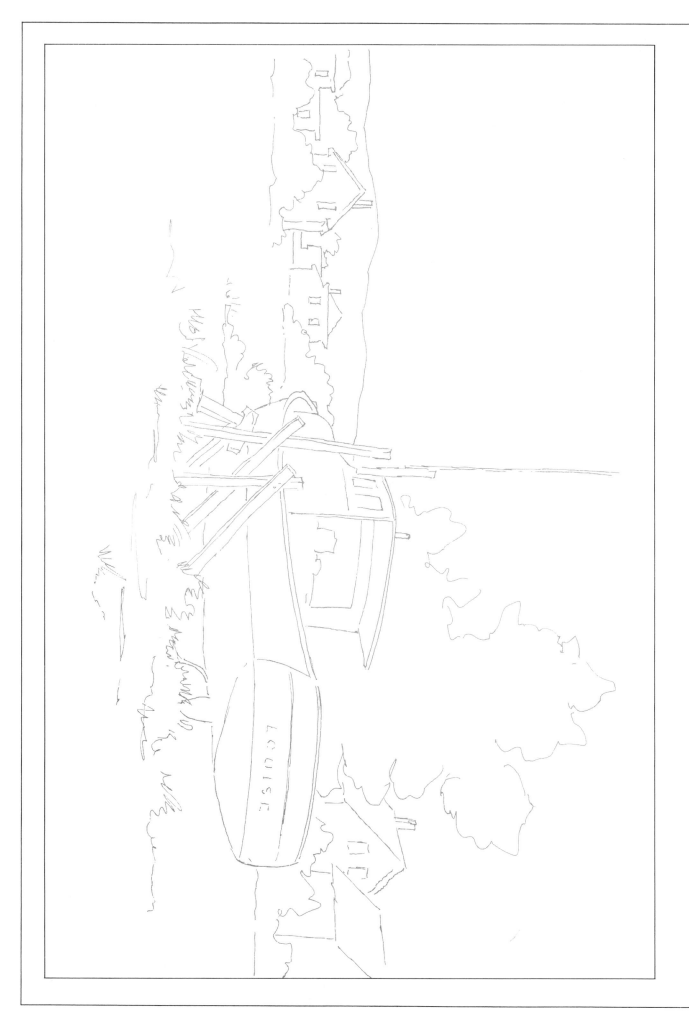

Color and Value Change

Take a look through your window. If you can see very far—say, a mile or more—you'll notice that distant objects appear much less colorful than they actually are. A distant skyscraper might look gray even though it's made of pink granite or green-tinted glass. Far-off hills or mountains look bluish or purplish, depending on how far away they are and what sort of weather you're having, yet you know they would not appear blue or purple if you were actually there, climbing them.

The reason the colors of objects seem different from a distance is that there is a sort of veil you're looking through to see them, and the farther away you are, the thicker the veil. The veil, of course, is the layer of air between you and the object. All air contains tiny water drop-lets and impurities such as automobile exhaust fumes and smoke and dust particles. The effect of this slab of not-quite-transparent air is to act as a filter, letting certain wavelengths of light pass through, but blocking others out. The cool colors (such as blues) get through most easily, while a lot of the warm colors (such as reds) get filtered out before they reach your eyes.

The actual content of the air varies from one region to another, even from one town to another, and it varies tremendously with the weather. But no matter how clear the day, distant things will still look bluer than similar nearby things; there is still a veil between you and what you're looking at.

Something else happens when we view things from afar. Distant things not only look bluer, but usually lighter in shade as well. **Below** is a country scene as it might appear in a black-and-white photograph.

Notice that the hills get lighter the farther away they are. If this were printed in color, the hills would be tending toward paler blues as they recede. Even the birds show up fainter when they are farther back in the painting. There is simply less light reaching our eyes from a distant object than there would be if we were close to the object. Again, part of the reason is that the veil of air is filtering out some of the light. A second reason is that the farther away an object is, the more widely diffused is the light given off by the object.

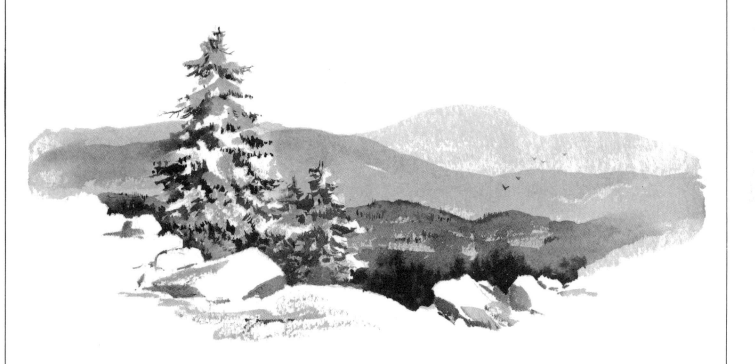

Color and Value Change

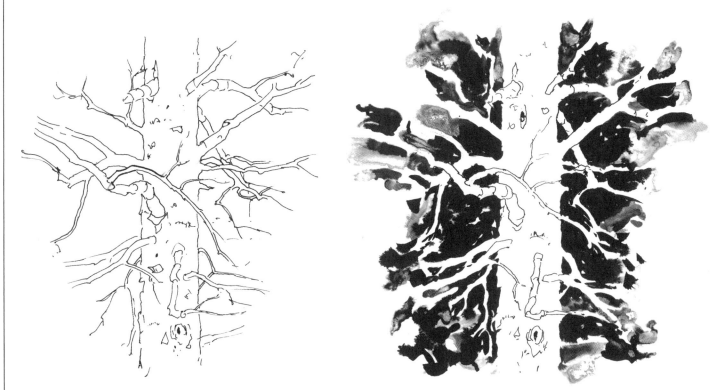

Painters, like everyone else, like to attach fancy names to things. Here are two of them: the lightness or darkness of an area is called its *value*; a light area has high value, a dark area has low value. (When a student asked a teacher I know to comment on the value of an area he had shaded in, the teacher grumped, "It's priceless.") Together, the two phenomena we've been discussing, color change and value change over distance, are usually called *aerial perspective*.

It's important to understand that there are many factors affecting how things appear at a distance, and no given scene will look exactly the same from one hour to the next, let alone one day to the next. More moisture or pollution in the air will alter things; a cloud casting a shadow over a distant hill can make that hill appear darker than the nearer ones, thus reversing our "rules"; a faraway, tree-covered hillside in the winter will appear cooler (more bluish) than that same hillside in the fall. What's really important to understand is that you have a great amount of leeway in cooling the colors and lightening the values of objects to make them *feel* farther away.

We tend to think about the obvious parts of a scene when we consider aerial perspective—distant mountains, a city skyline miles away—those things that tend to look bluish or grayish. But how about things that are nearer and not at all blue or gray? Consider a red barn in a

yellowish meadow. If you're placing the barn and meadow prominently near the foreground of your painting, then paint them as red and yellow as you please. But if this same barn and meadow are a quarter-mile away and you paint them as red and as yellow as they really are, they'll jump forward and fall out of the front of the picture. Warm colors tend to come forward and cool colors tend to recede, so to push an object farther back into the picture, make its color more cool (or less warm). Dull that red for the barn just a little—try a dab, and see how it feels. If it still shouts "Gangway! I'm coming forward!" then dull it a little more until it feels right for the distance you're giving it in the painting. The same goes for the yellow meadow. Perhaps up close it looks as bright as cadmium yellow, but maybe to push it back you need yellow ochre.

I hope you don't take any of this as anything more than guidelines. There are many factors affecting the look and feel of your painting, so don't be caught concentrating too much on one facet. Don't, for example, slavishly dull down the red paint for the barn without considering also the colors that adjoin the barn. If the barn is set against a backdrop of, say, green woods, you may need to dull the red more than if the backdrop were brown autumn foliage, because green is a complementary color to red and its presence tends to make any red look

even redder. If there is any rule in painting, it's this: Learn all the devices and techniques and tricks and goofball ideas you can, but then keep your eye on how the whole painting is developing, rather than some isolated part; and then trust your instincts. The more you paint, and the more you look at other people's paintings, the more trustworthy your instincts will become.

Lest I leave you with the notion that areas in the background must always get lighter than the foreground areas, look at what happens to the sketch **above left** when we *darken* the background, **above right**. The value contrast separates the tree from its background and seems to thrust the tree forward (or the background back).

Further depth can be attained by employing some of the other techniques, such as modeling the trunk and branches to make them feel round. Using ordinary pencil or diluted ink or watercolor, do some careful modeling right on one or both of these sketches. Be sure to decide first the position of the light source in the scene, and then do your modeling accordingly. If you choose a light source toward the left, for example, darken the trunk more around the right side.

Color and Value Change

The tree illustration demonstrates that you can introduce separation between areas, and therefore depth, simply by having a fairly strong change in values. In that example we went from light foreground to dark background. In the sketch **above**, the same sort of thing is accomplished, but in this case we go from dark to light. An abrupt value change in either direction is often a good vehicle for introducing depth. Such a value change has not much to do with great distances or veils of atmosphere. It simply works!

Exercises: **Color and Value Change**

Color Change

Color in the scene on the following page with colored pencils (or paint, if you prefer). You might make the sky simply blue and white, the trees greenish, the barn roof gray, the ground areas yellows and greens, the path, roadway, and fence posts brown. Don't color in the mailbox flag (1), the barn front (2), or the brick house (3).

Make at least three tracings of the barn front and the brick house. Transfer the tracings to paper you can paint on, and cut them out. Let's assume that in the actual scene all three numbered areas are the same red. Pick a fairly strong red and paint all three areas (1, 2, and 3) with that same red right on this practice sheet. Notice that the barn and house don't yet feel as distant as they should.

Now use the same red, slightly dulled, to paint one of the cutouts for the barn. Lay the colored cutout on the painting and see if it feels right. Too red? Color another cutout, this time dulling the red even more. Still too red? Try again on another cutout, but this time in addition to *dulling* the red, try making the color less intense as well—that is, lighten its value. When you finally get a red barn that feels right, dull the color even more and use it on a cutout of the even more distant house. When you get finished, there should be a noticeable dulling of the reds as you go back into the scene and a greater feeling of depth than there was when all three objects were painted the same red.

You might trace off the entire scene, transfer the drawing to another sheet of paper, and do some further experimenting with other receding colors. This time imagine the flat ground areas to be either yellows or greens. Make the front ground areas the brightest greens (or yellows), the middle areas more subdued greens (or yellows), and the distant areas still less bright.

Value Change

First, make several copies of the sketch on page 22 by tracing it onto pieces of ordinary typing paper. Then, using colored pencils or pastels, carefully color one copy of the scene on page 22 as a winter scene: Make the most distant hills very cool (blues) and light in value; middle areas progressively less cool and darker in value; and the foreground essentially white with snow on the ground and on some of the branches of the large tree. Although the foreground will thus be the lightest value of all, it will not automatically recede because you'll include enough detail and sharp edges to make it seem close to the viewer.

Then on another copy of the same page, create a fall scene from the same sketch: Make the most distant hills light in value and cool in color, but not as cool as in the winter scene—try more purplish than bluish; intermediate hills gradually warmer; foreground, detailed trees and rocks, with plenty of touches of warm colors.

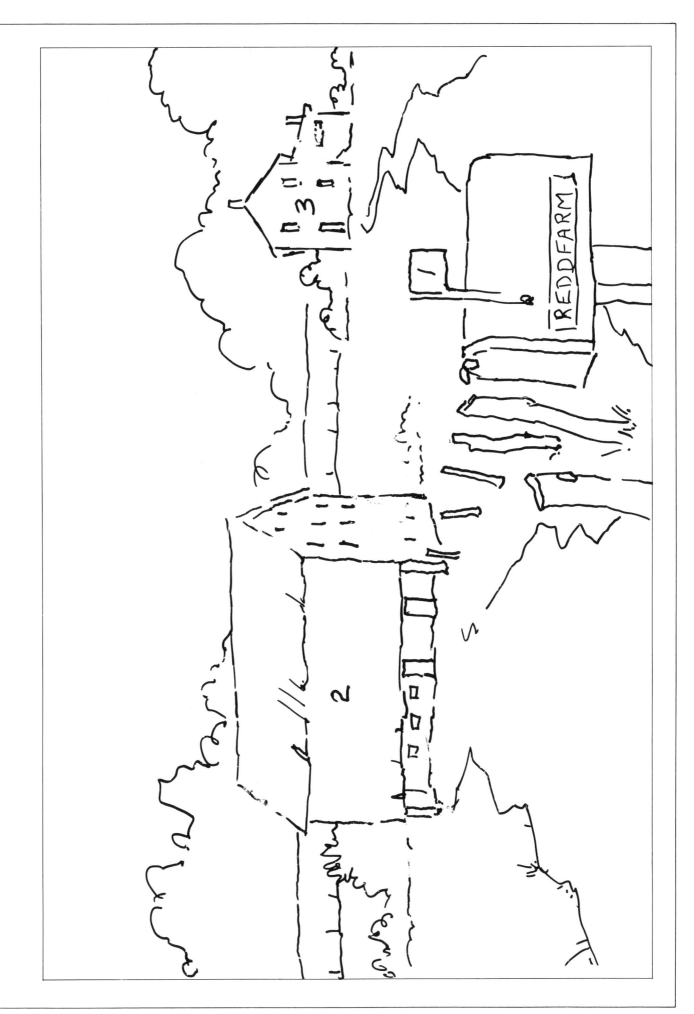

Converging Lines

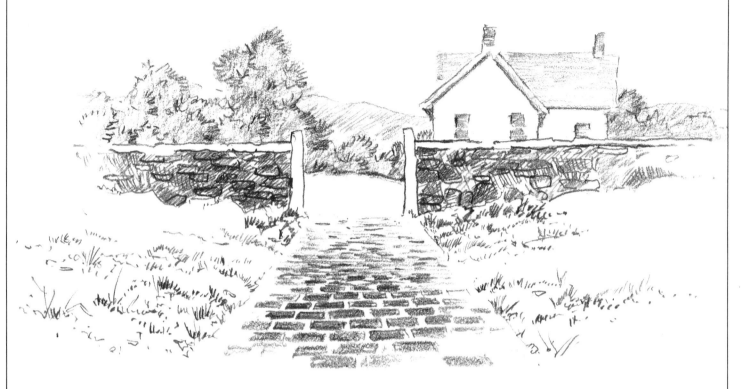

Stand with your back to the wall in any room in your house or office and face the opposite wall. If yours is a "normal" rectangular room, you'll find the left and right walls seem to be closer together at the far end of the room than at the end where you're standing. The lines where the side walls meet the ceiling seem to be converging and would apparently meet somewhere if they were extended far enough.

Flip back to some of the earlier illustrations in this book, such as the train station on page 8. Notice that the tracks seem to be converging as they go off into the distance. You know that they do no such thing—if they did, the first train to come along would be in a lot of trouble! In that same picture, notice that the buildings seem to squeeze smaller as they recede. If you draw light lines extending the main roof lines and the foundation lines toward the right you'll find that they meet at a point approximately along the bottom edge of the distant row of trees. Now do the same with the straight portions of the train tracks—extend them and you'll find they meet at a point along that same horizontal line at the base of the distant trees.

Look at the brick walkway in the sketch **above**. You can pretty much assume this path is about the same width all the way along, but there it is squeezing together as it recedes from you.

It's the way we see things. Lines that we understand are really parallel to each other seem to converge as they recede from us. We intuitively understand this apparent convergence as representing depth, or distance. In drawing and painting we make use of this understanding to give our pictures the illusion of depth. The use of converging lines to suggest depth is usually called *linear perspective*, and it's one of the most effective of all the perspective techniques.

Converging Lines

Some definitions are in order. Imagine yourself on a long, straight road in Texas that stretches away over miles of perfectly flat land and finally disappears on the horizon. We all understand the horizon to be an imaginary horizontal line where the sky meets the land or water. The two sides of our road will appear actually to meet at the horizon, and the point where they seem to meet is called a *vanishing point* (VP). It's where the road "vanishes."

Next we need to understand something called the *eye level*. The eye level is simply an imaginary plane passing through the eyes of the artist or other viewer of a scene when he or she is looking straight ahead. In our Texas example, the eye level is synonymous with the horizon. In fact, they're always synonymous, but because there are times when you can't actually see the horizon (there may be mountains, buildings, or other objects in the way) we discard the use of "horizon" in discussions about perspective and use the safer term, "eye level," instead.

Establishing the eye level in a realistic picture is crucial because, as you'll soon see, everything else in the picture is drawn relative to the eye level. To illustrate, consider the three sketches at **right** representing our Texas highway.

In the first, imagine you're simply standing and looking straight ahead to where the road "vanishes"—the vanishing point. Then suppose you lower your eye level by lying with your chin on the ground and looking straight ahead. What you'd see is something like the second sketch (less ground, more sky—a worm's-eye view). Now suppose you're carried aloft by a Texas-sized buzzard and again you look straight ahead to where the road "disappears." Now you'll notice more land beneath you and relatively less sky, as in the third sketch.

Remember: The eye level (EL) is the horizontal level in line with your eyes when you're looking *straight ahead.* The eye level does not change when you tip your head back or forward, or when you roll your eyes up or down.

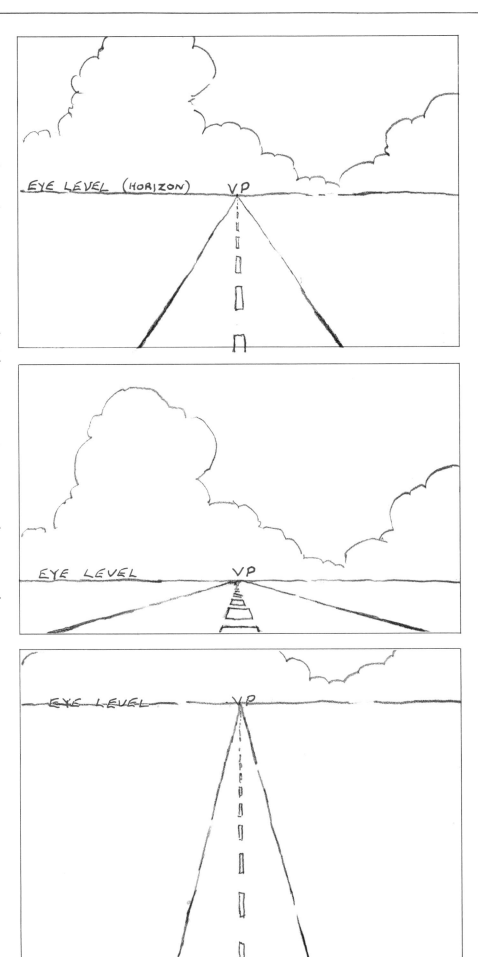

Converging Lines

Let me put it another way:

The eye level in your picture tells the viewer of the picture how high up you were when you painted it. Once you've established how high you are in relation to your subject, it doesn't matter whether you look up or down.

For instance, suppose you're drawing a bird in a nest on a limb above your head, **below right**. The eye level in that scene will be low. You'll be seeing the bird and nest from underneath.

Now suppose you draw a nest in the grasses at your feet, **below left**. The eye level is very high, so high that it's out of your picture.

The eye level changed between these two scenes because your physical relationship to the subject changed (in this case, the nest changed places, but the effect is the same whether it's the artist or the subject that moves).

In both these examples, you had to bend your head either up or down to see and draw the subject. But that didn't affect the eye level. The earth's horizon never changed, did it? No matter how sharply you look up or down, the horizon, or eye level, stays put.

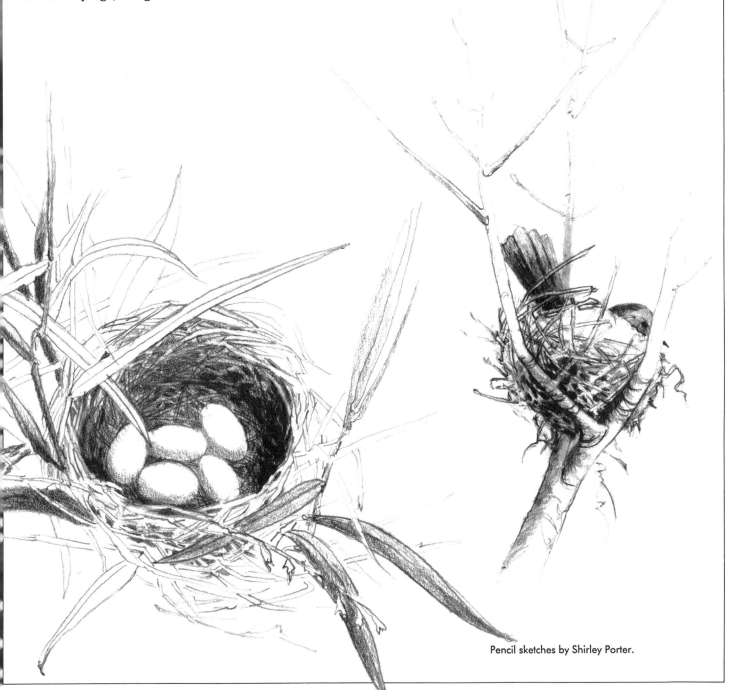

Pencil sketches by Shirley Porter.

Converging Lines

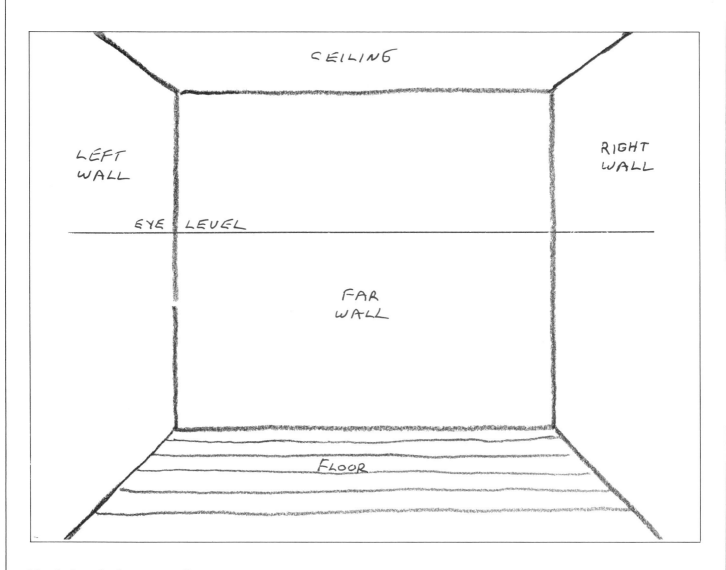

Now let's go back to your ordinary rectangular room and assume you're standing smack in the middle of it, facing an end wall. You're far enough back that you can see portions of walls, ceiling, and floor, as shown **above**.

If your eyes are, say, five feet above the floor, then the eye level in the scene you are witnessing is also five feet above the floor. If you decide to paint this scene as you see it from where you're standing, you'll need to draw lightly (or at least imagine) a horizontal line across your canvas representing the eye level in the scene you're about to paint, and then you must relate everything in the picture to that eye level.

Converging Lines

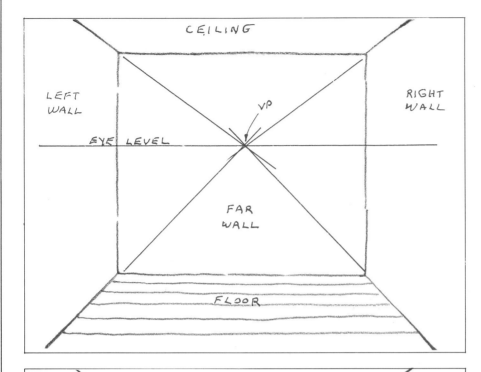

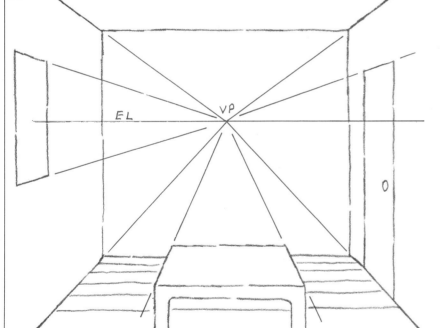

In a scene such as this there is a single vanishing point (VP). If you're standing equidistant from the two side walls, the VP is halfway across the far wall and five feet up from the floor (the height of your eyes). If a child were painting the scene from the same spot, the eye level would be much lower and the resultant painting quite different from yours. The child would see more ceiling, less floor.

In this simple room there are some horizontal lines receding from you. The lines where the ceiling meets the walls are above your eye level, and they seem to aim downward toward eye level. The lines where the floor meets the walls seem to aim upward toward eye level. In fact, if you mentally extend all four of those lines into the distance you'll find that they all meet at a single point (the vanishing point), and that point sits right on the eye level.

In the second sketch I've added a few simple items to the room: a low table, a window, and a door. Look at the receding "horizontal" lines in each of those objects. They all meet at the same VP.

Converging Lines

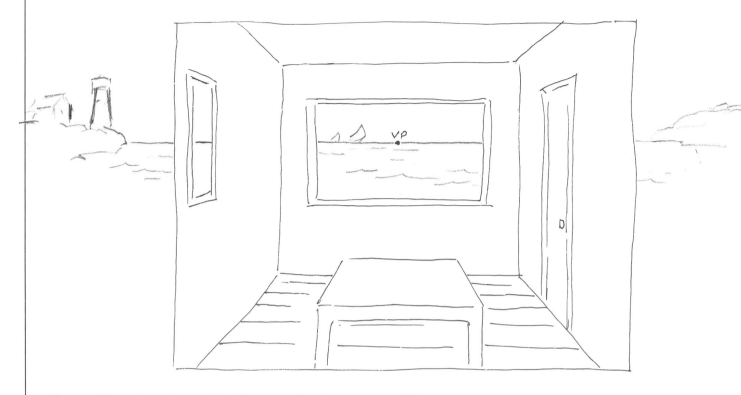

If you could see through the wall and far enough into the distance, you'd see the earth's horizon passing through the vanishing point. I've put a large window in the far wall so you can see this effect.

What we've sneaked up on here is a technique called *one-point linear perspective*. There is only a single vanishing point in the scene, and one face of the object being drawn (the room) is parallel to the picture surface. Had we not arranged things so neatly—for example, if the table had been turned at an angle, or we had faced a corner rather than the far wall—we would have found that not all parallel lines in our picture converged nicely to a single point. There would have been two or more VPs. We'll get to that in Part Two.

Converging Lines

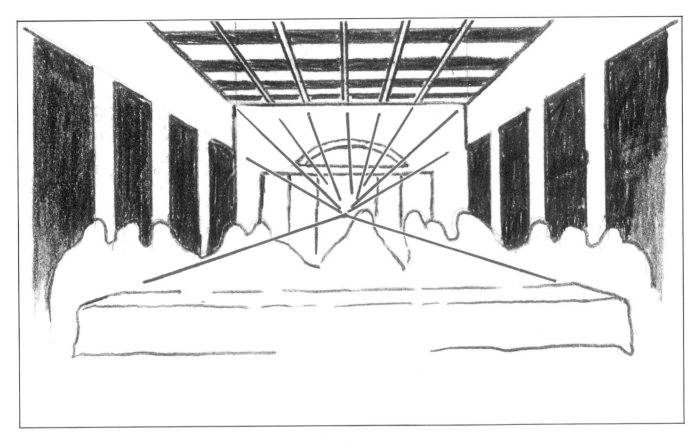

One-point linear perspective is not used as extensively in present-day art as two-point. One-point tends to be static and formal, and we're not too static and formal these days. A couple of centuries ago, however, this form of perspective was used often. A good example of its use is Leonardo's *Last Supper*, which I've sketched here.

Where do we use one-point perspective these days? It's quite often used in portrait painting, where the artist attempts to focus attention on the subject of the portrait by arranging the surroundings in one-point perspective. For example, Leonardo's work focuses attention on the central character by making the receding lines in the room converge very near Jesus' head. Often in landscapes where I have a number of buildings in two-point perspective, I include at least one building in one-point to help settle things down. Too many objects in two-point can be confusing or unsettling, but the inclusion of an object in one-point can help restore a little order, a sense of calm. Again, we'll discuss this further in Part Two of this book.

Something you'll notice about receding horizontal lines, besides the fact that they all meet at a vanishing point: the lines below eye level will slant UP to meet the eye level and those above the eye level will slant DOWN to meet the eye level.

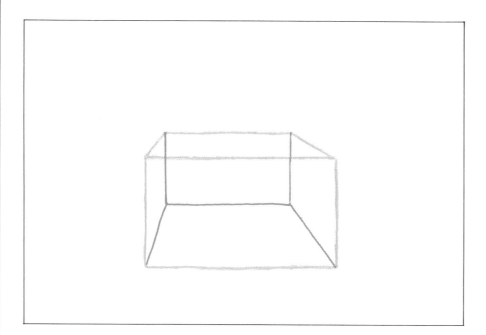

Let's construct a simple box, like the one shown here. Using the front face of a rectangular box provided on page 33 and the eye level indicated, follow the construction steps to add the rest of the box, including the hidden edges.

After you've completed a box using the face given, construct your own front face on a blank sheet of drawing paper, establish an eye level, and repeat the exercise.

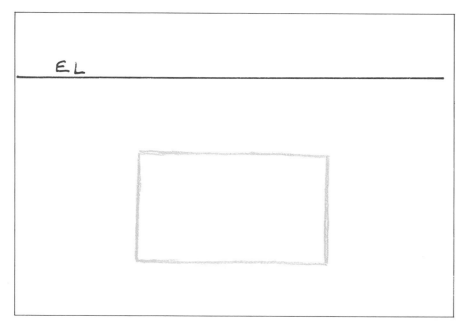

Step 1: Imagine this to be a glass box so that you can see the rear edges and corners. The front face is parallel to the picture surface and the box is below eye level.

Exercise: **Converging Lines**

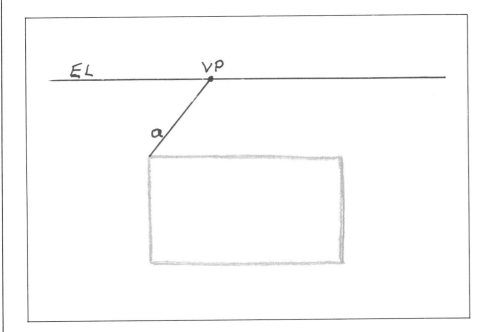

Step 2: Depending on where the viewer is standing—at center, or left or right of center—the vanishing point may fall anywhere along the eye level. Let's assume the viewer is a little left of center (a socialist, maybe) so the VP will be somewhere left of center. But where? If you were actually seeing and drawing this box, you might hold a straightedge at arm's length, angle it to match the angle of one of the receding edges of the box, carefully move the angled straightedge to your drawing surface, and sketch in that edge on your drawing alongside the straightedge. Let's say the resultant edge of the box is line *a*.

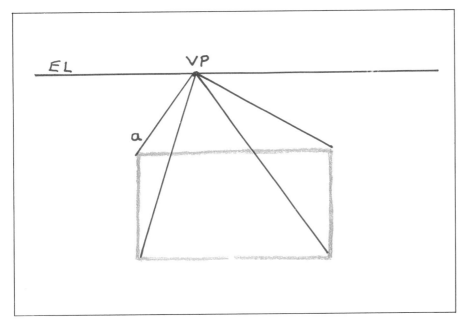

Step 3: The rest is easy. Where line *a* meets the eye level, you have your vanishing point (VP). To get the other three receding edges of the box simply connect the remaining corners of the front face to the VP. Notice that, in accordance with our guideline, since the box is below eye level all receding edges slant UP to meet the eye level.

Exercise: **Converging Lines**

Step 4: The next thing to determine is how deep this box is. In practice you estimate that by eyeballing the scene before you and comparing the depth of the box to other dimensions, such as the height of the box. Whatever you arrive at will be your best guess. Draw in line *b* where you think it belongs. If it doesn't look right, move it forward or back until it does.

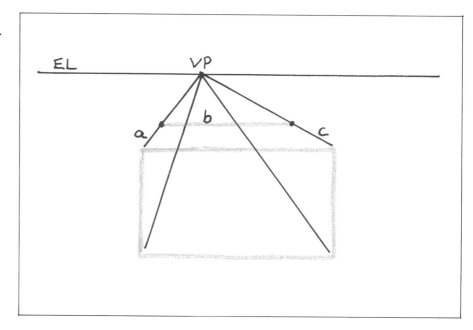

Step 5: This is probably a good place to tell you something you already have a sneaking suspicion is true: There's a lot of complicated geometry you can use to arrive at various lines and angles in a perspective drawing to get it just right. But unless you're an architect or a nitpicker beyond all redemption, forget it. If you get too technical, you'll only succeed in draining your art of its creative spark. You'll end up with a drawing that's technically accurate, but nobody will care and you'll be exhausted.

Back to our glass box. It's finished, if you simply erase the construction lines. But this is a glass box for a reason—I want you to be able to visualize the normally unseen rear edges. To locate them exactly, draw vertical lines through the points where line *b* intersects lines *a* and *c*.

Where those vertical lines intersect the bottom receding edges, you have the remaining corners of the box. Connect those corners with line *d*. Now erase unneeded construction lines, and there you have it.

So far we've said little about vertical lines. We've just left them vertical. No vanishing points, no slanting, no pizazz at all. The reason we leave vertical lines alone is this: In the great majority of the subjects we choose to paint, the vertical lines are relatively short, and any point along a vertical line seems roughly the

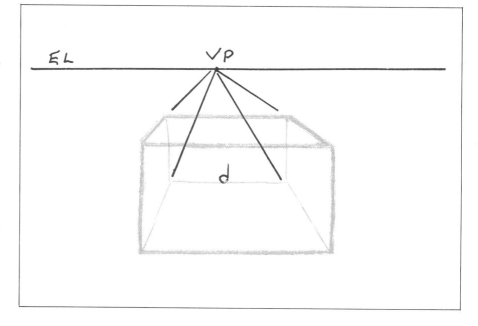

same distance from our eyes as any other point along that line. There is no illusion that the line is moving away from us. In Part Three, however, we'll deal with vertical lines that are so tall that a pair of them rising skyward or diving into a valley will indeed be moving "away" from us and will seem to be converging toward a vanishing point just as horizontal lines, such as railroad tracks, seem to converge as they move away into the distance.

EYE LEVEL

Vanishing Point and Eye Level

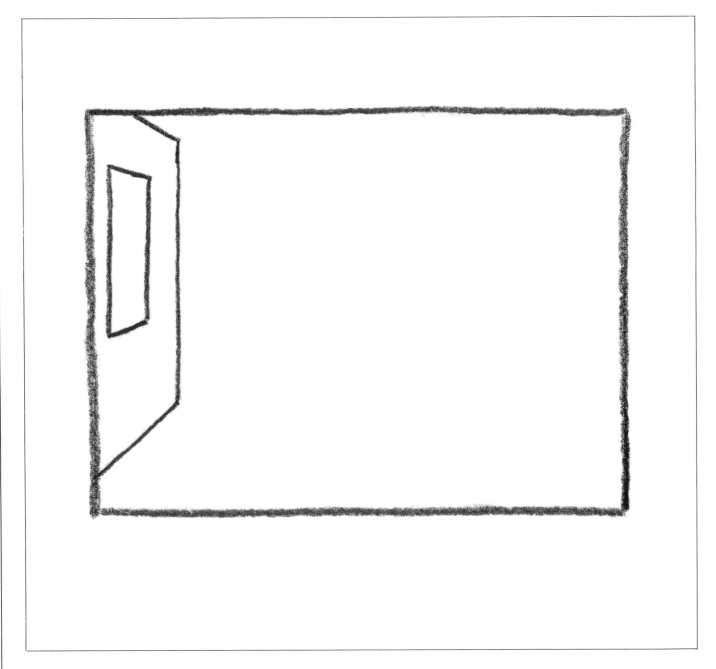

Here's a room drawn in one-point linear perspective, with one side wall established. Extend the top and bottom of the existing wall to find the VP. Then draw in the eye level and the right wall, ceiling, and floor. (Remember, the eye level is simply a horizontal line drawn through the VP.)

Exercise: **Vanishing Point and Eye Level**

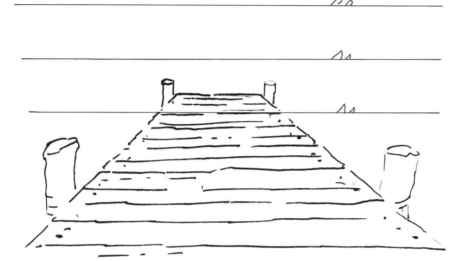

Here you're standing on a level dock looking out across the water at the horizon. Choose the most logical horizon and draw it in.

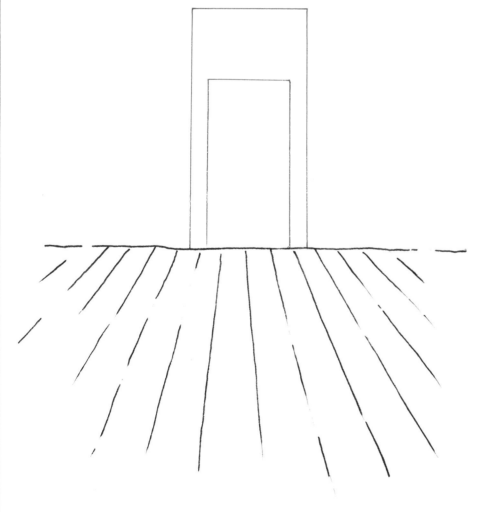

You're six feet tall and standing on a level board floor looking straight ahead at an opposite wall. The wall has a normal seven-foot doorway in it. Choose the most appropriate doorway and draw it in.

The correct choices are the middle horizon and the smaller door.

Exercise: **Vanishing Point and Eye Level**

Here are portions of three rectangular boxes. Finish drawing each in one-point perspective, using VP as the single vanishing point for all three.

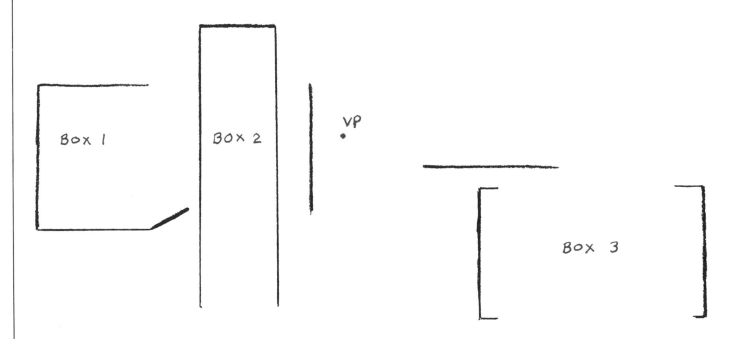

Estimating Angles

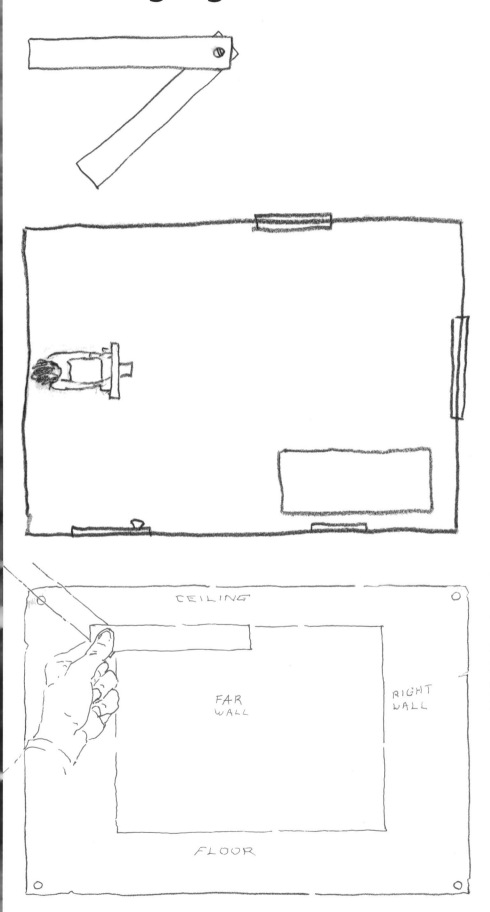

Linear perspective involves the constant observation and drawing of angles. Here is a useful technique for estimating angles accurately. First, make a simple angle-measuring device shaped like scissors. Cut two strips of cardboard about eight inches long and an inch wide. Fasten the strips together at one end with a paper clasp, a thumb tack, a screw, or whatever. The idea is to hinge the two strips so that they're snug but movable. You could also use a folding carpenter's rule, if there is one handy.

With your back near one wall of a rectangular room, set up a piece of paper on your easel at arm's length in front of you, as shown at **center**.

Using charcoal, draw in a rectangle roughly representing the far end of the room. I've roughed in a faint outline of a typical far wall, but yours may have different proportions; if so, change my sketch.

Now use your cardboard measuring device to find the angles at which the side walls, ceiling, and floor seem to meet that far wall. Here's how. Hold the device at arm's length so that it always stays *parallel to that far wall* (and parallel to the paper on your upright easel). Use the cardboard scissors to measure an angle — let's say the angle between the horizontal top of the far wall and the line where the ceiling and left wall meet. Don't swivel the scissors to match an angle — keep the device flat (parallel to the far wall) and vary only the amount you open or close the hinged jaw. When the angle between the cardboards matches the angle you're measuring, carefully move the cardboards, still at arm's length, to your paper and trace off the angle. Do the same for any angle you want to capture, including the shapes of picture frames, doors, windows, etc. With practice you'll learn to keep the measuring device parallel to your paper and not let it swivel in your hand.

Part Two:
Boxes and Beyond

John was one of my students a few years ago. He was impatient. He loved to disagree. He insisted skies were blue and white and it was ridiculous for me to demonstrate one that was purple and gray. One evening I was demonstrating some simple two-point perspective.

"Phil, why bother?" It was good old John.

"Why bother with what, John?"

"With all this construction."

"Because sometimes it's tough to get down on paper what you see and it's good to have some basics to fall back on, John."

"But we all know how to draw things in perspective."

I was a very patient teacher, I think, but occasionally my patience deserted me. I said, "John, how about your farm scene, the one we critiqued last week . . . didn't we find a couple of perspective problems there?" Actually, he had drawn one barn sliding off the left side of the paper and another seemed to be sinking into quicksand.

"Naw, Phil," he laughed, "it was just cold the day I was painting . . . little too much brandy in my coffee!"

"Well," I went on, smiling and trying to address the whole class, "I know that people get scared of perspective because they think it's mysterious and complicated . . ." John was settling back and his eyelids were getting heavy. "But basi-

cally it's pretty simple. It's just a set of ideas that help you to make solid drawings of solid things." I threw an eraser in John's direction and jolted him awake. "Right, John?" I laughed and John semi-smiled.

"Now," I continued, "I don't want to leave the slightest impression that a creative painting or drawing is something bound up in rules. What we call perspective is just another set of tools that'll *help* your creativity, not hinder it. The more you know of techniques, tricks, and tools, the more you can let loose and free up your creative tendencies. Right, John?"

"You're the teacher, Phil," said John with playful sarcasm.

I decided to take one more stab at convincing John he ought to pay attention to perspective.

"Look at it this way, John. Learning what happens to an object in perspective is really no different from learning that mixing red and yellow gives you orange. These are simply part of the store of knowledge you accumulate and tuck away in your brain, and then call on automatically when you're creating a picture. You won't normally say, 'Now let's see, this line has to go to this vanishing point and that line goes to that vanishing point' any more than you would say, 'Now, let's see, I need blue and yellow to mix a green.'"

"How's that again, Phil," John was

suddenly awake and scribbling in his notebook. "Blue and yellow make what . . . ?"

In Part One we discussed a variety of techniques useful for getting a feeling of depth in a painting or drawing. These techniques are usually lumped together and called perspective. The last perspective technique we discussed was linear perspective, the use of converging lines to suggest depth. When we draw something in linear perspective, all we're doing is making lines that are actually parallel to one another appear to converge at some distant vanishing point. Like all the other perspective techniques, this is simply an imitation of how our eyes and brains actually interpret things.

In Part Two we'll concentrate on drawing rectangular objects in linear perspective. Most of the other things we draw can be thought of as variations of rectangular objects, so once these are mastered you can draw practically anything in perspective and get it right.

In the examples so far, we've dealt with one-point linear perspective—simple situations in which all receding lines meet at a single vanishing point on the horizon, or eye level. Here we'll deal with a more common situation, two-point linear perspective. This means we have two vanishing points, with some lines receding to one of them and some to the other.

A Simple Box in Perspective

Lay a straightedge along each of the seven lines in this box and use a pencil to extend each of them a few inches in both directions.

What do you see? First, the vertical lines stay parallel to each other and apparently don't plan to meet, no matter how far you extend them. But the other lines, the "horizontal" ones, do meet. The right-hand ones meet at a point to the right, the left-hand ones meet at a point toward the left. Now use a straightedge to connect those two meeting points.

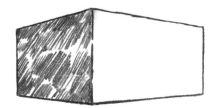

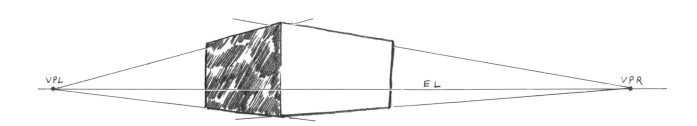

The second sketch establishes some names we'll use. The point where lines meet at the right is *vanishing-point-right,* or VPR, and the one on the left is *vanishing-point-left,* or VPL. The line they lie on is the *eye level,* EL. These are the same terms and concepts we used in Part One, except now we're dealing with two vanishing points instead of one.

The difference between this box and similar objects discussed in Part One is that none of the faces of this box are parallel to the picture surface. Both visible faces of this box are turned away from the viewer into the distance, and their horizontal edges meet at one of two vanishing points.

A Simple Box in Perspective

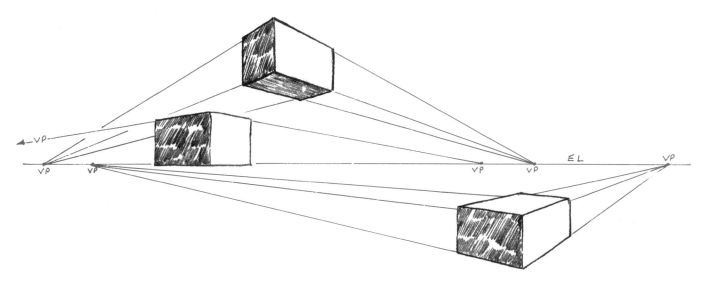

Here I've shown three boxes, one with its bottom at eye level, one above, and one below eye level. Each is twisted at a different angle from the viewer.

Notice something very important in this "scene": Each box has its own pair of vanishing points, but all the vanishing points lie along the same eye level. These boxes could represent houses in a village with hills and valleys. Each house would have its own set of vanishing points, but the entire scene would have only a single eye level, and the vanishing points for all the houses would fall on that eye level.

So let me repeat something from Part One: When you draw any scene, first es-

tablish the eye level from which you wish to view the scene, and then relate everything to that eye level. It makes sense, doesn't it? If you draw one object as it would be seen at one eye level and another object as it would be seen from a different eye level, how could the two objects possibly feel right together in the same painting? This would work for an observer from another planet with eyes in both his head and in his knees. Here on our mundane earth we have to be content with one set of eyes per humanoid. Choose an eye level and stick with it!

Drawing Through

To draw or paint a three-dimensional object convincingly you need to understand its volume—you need to be able to "get your arms around it" mentally. If you can "feel" the roundness of a tree trunk, you can better get it down on paper as a thing that has thickness; if you only see the trunk as a flat shape, you'll probably draw it as a flat shape. A way to train yourself to capture the volume of an object is to constantly draw its hidden lines, especially when you do your rough, preliminary sketching.

Here we have a flashlight, an electric pencil sharpener, and a shed. In these sketches I've tried to remind myself of the depth these objects have. The flashlight is not just the flattish surface I see when I glance at it, but rather something that curves away and around and back again—it even contains round batteries that I can't see, but I sketch them in anyway to help me feel the solidity of the subject. Including the batteries also serves as a check on the flashlight's proportions; had I found I had left too much or too little space for the two batteries I know are in there, I would have shortened or lengthened the shaft of the flashlight. The pencil sharpener and the shed are relatively simple-shaped objects, but even so they can give you a fit if you don't locate (at least mentally) their hidden corners and edges. Roughing in some construction lines and finding those edges and corners can make the difference between a solid, convincing drawing and a drawing that is unexplainably out of kilter.

Sketching in this way is sometimes called *drawing through.* Draw through an object and see where it goes when you're not looking.

In Part Three we'll further explore the value of drawing through when dealing with curved or odd-shaped objects. Right now we're concerned more with the rectangular box, but even here it's extremely helpful to be able to "see" through the object.

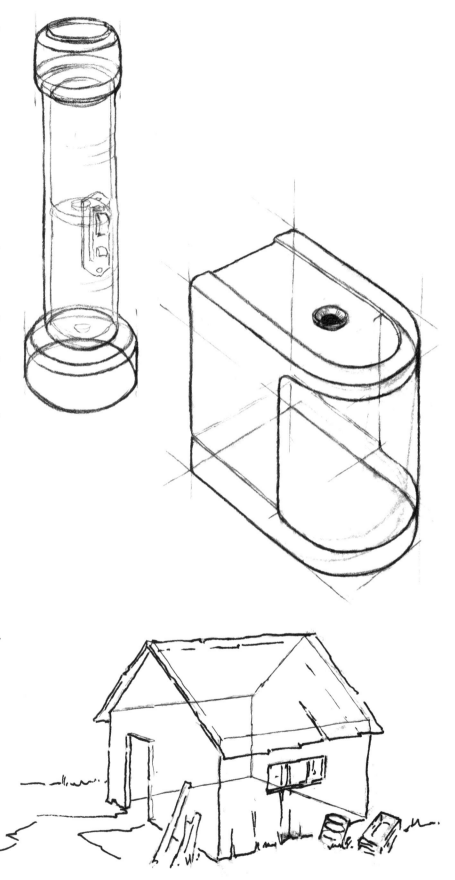

Finding Hidden Edges

Let's return to the simple box and see how to locate its hidden edges. Follow me a step at a time, drawing right on this sketch.

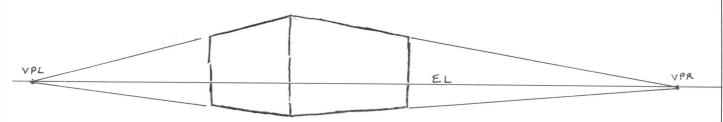

First, let's locate the vanishing points, VPL and VPR. Do this by extending the horizontal edges of the box until they meet. Then draw in the eye level (EL), connecting VPL and VPR.

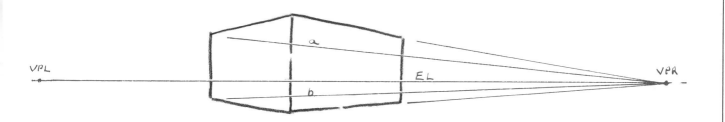

Where are the rear (hidden) walls in this box? What are their shapes and where do they meet? If we can figure out where they meet, we'll have the rear-most (hidden) vertical edge of the box.

Actually, it's easy. The hidden horizontal edges of the box obey the same rules as the visible horizontal edges: they slant toward the appropriate vanishing points. Connect the leftmost vertical edge with VPR. Do you see that line *a* shows the slant of the rear upper edge of the box as it recedes toward its vanishing point, and line *b* shows the slant of the rear lower edge as it recedes toward the vanishing point?

Finding Hidden Edges

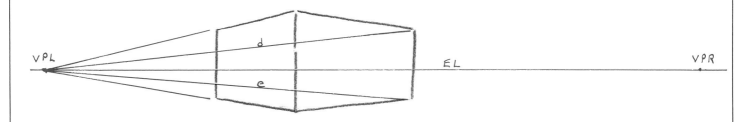

Now connect the rightmost edge of the box to the other vanishing point with lines *d* and *e*.

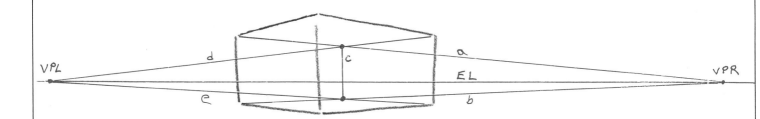

The right-slanting lines, *a* and *b*, define one of the hidden walls, and the left-slanting lines, *d* and *e*, define the other hidden wall. Where those two walls meet is line *c*, the hidden vertical edge of our box.

Lines *a* and *d* should meet at a point directly above the point where lines *b* and *e* meet, but unless you're a lot more careful than I, they won't exactly. Don't worry about it. You're sketching a box, not designing a bomb. Only if you use the most extreme care in all your geometry will things come out perfectly, but it's not worth the bother.

If we erase unnecessary construction lines and imagine our box as transparent, we see something like this. An understanding of this construction will enable you to draw practically any rectangular object with authority.

Exercise: **Hidden Edges**

Here are the beginnings of three boxes. For each one, an eye level and two vanishing points have been established. In each case I've shown the most forward vertical edge of the box. Complete each box, placing the remaining vertical lines wherever you wish to establish the lengths for the sides of the boxes. If you have trouble, look back at pages 43 and 44. Use black pencil to represent lines that would be visible to a viewer and colored pencil for "invisible" lines.

BOX 1

VPL
EL 1
VPR

BOX 2

VPL
EL 2
VPR

VPL
EL 3
VPR

BOX 3

Playing with Vanishing Points

So far, I've been pretty dictatorial. I've told you where the vanishing points are, period. But when you're out there sketching, you're on your own. How do you know where to put the vanishing points?

Let's assume you're beginning the drawing of a barn. First, you might lightly draw in the vertical barn edge that's nearest you. Then you could find a pair of horizontal edges that seem to be receding from that vertical edge to a vanishing point. Let's say the two horizontal edges were the roofline and the foundation line on one side of the barn. You'd hold a straightedge out in front of you and slant it to match the slant of the receding roofline, then move the straightedge to your paper (maintaining the slant) and lightly sketch in the roofline. You'd do the same for the foundation line. Where the two lines met on your paper would be one of the vanishing points. You might need to make several attempts at this before getting something that seems right because you're liable to change the slant of the straightedge as you move it to your paper. With a little practice this will no longer be a problem.

Next, you'd do the same thing with the other side of the barn—that is, locate its vanishing point using the straightedge.

All's well if both vanishing points end up neatly on your paper, but often one or both seem to fall somewhere beyond the edges of your paper. Frequently, one vanishing point may seem very far to the side. You can do one of two things about this:

1. If it's feasible for you to temporarily tack on additional paper alongside your picture and locate the vanishing points on this temporary paper, go ahead and do so. This may be reasonable if you're working at a desk and have room to lay out the paper to the right and left of your drawing; in the field, it's rarely reasonable or convenient.
2. If you can't use temporary paper, forget about actually putting down a point that says "vanishing point." Instead, just sketch in guidelines that, if extended far enough off your paper, would meet at a vanishing point. In other words, you keep a mental picture of where the vanishing point is but never actually put it down on paper. The guidelines aiming toward the vanishing point are really all you need. After all, the only reason you need vanishing points in the first place is to help get the correct slant on various lines in your drawing. What you end up doing, then, is comparing the slants of all the lines you draw with the slants you established with your straightedge. Obviously, you could use the straightedge to get the slant of every line you draw, but that's tedious and unnecessary. Once you establish a couple of basic guidelines with the proper slant, you can use them to estimate the slants for all your other lines.

What's Legal?

Suppose you're looking at and drawing a scene and decide you want to change the locations of the vanishing points. Is that legal? ANYTHING IN DRAWING OR PAINTING IS LEGAL IF IT GETS YOU WHERE YOU WANT TO GO. Let's face it—our lives are governed by all kinds of laws mostly intended to keep us from harming ourselves or our neighbors. But in your own art, you are free to do whatever you wish, short of copying someone else's ideas. Of course, you may be the only one who likes the result, but that's another matter.

You may ask how such a law can be stated in a book full of directions about how to draw in "proper" perspective. The answer is this: If you first learn to draw things as they really are and as most normal humans would see them, you have a foundation from which you can extrapolate. Your art can become as strange and twisted and warped as your frenzied brain can make it, but it's easier to get anywhere if you start from somewhere. You only need look at the very early works of Picasso to see what I mean. He started with perfectly "normal" images—for example, people whose parts were all in the usual places—and ended with pictures of people whose parts were wherever he damn well pleased to put them.

Playing with Vanishing Points

Taking Liberties

Here is a picture I painted from inside an old shed I once owned. The shed had been whacked off its foundation by somebody using it as a garage and trying to squeeze too long a car into it. Using some hydraulic jacks and a lot of sweat, I raised the two sides of the building that were off the foundation. Then I wrapped a huge rope around the whole building, tied it to the bumper of my '65 Chevy, and tugged the building off the jacks and back onto the foundation. As the shed groaned more or less into place, I avoided making eye contact with a neighbor watching with a bemused look. She was sure that more than the shed was off its foundation!

I got the shed pretty much back in place, but it was never again really plumb. As a homeowner I wasn't crazy about that, but as a painter I liked it and painted pretty much what I saw. You might use a straightedge to extend some lines in my painting and see for yourself how they "almost" meet at proper vanishing points.

There's plenty of linear perspective involved here, forcing the eye through the various openings and off into the distance. The fact that some lines don't meet neatly at proper vanishing points doesn't matter. The perspective lines aim in the right directions and are accurate enough to make this a plausible building but inaccurate enough to suggest age and, in this case, mistreatment. Because I had had some experience observing how things are built I could make reasonable judgments about what to "straighten up" in my painting and what to leave cockeyed. I was able to keep some lines and shapes that were not quite "correct" but not have the painting look as though I simply didn't know any better. Incidentally, notice that there are perspective techniques other than linear perspective at work here:

- *Size variation*: boards in the near wall are wider than those in the distant attached shed; and the distant doorway seems much smaller than the nearest doorway, even though they're really the same size.
- *Value change*: the sudden switch from dark interior to sunlit exterior and back again to dark interior forces a feeling of stepping back into some distance. There is also a strong color

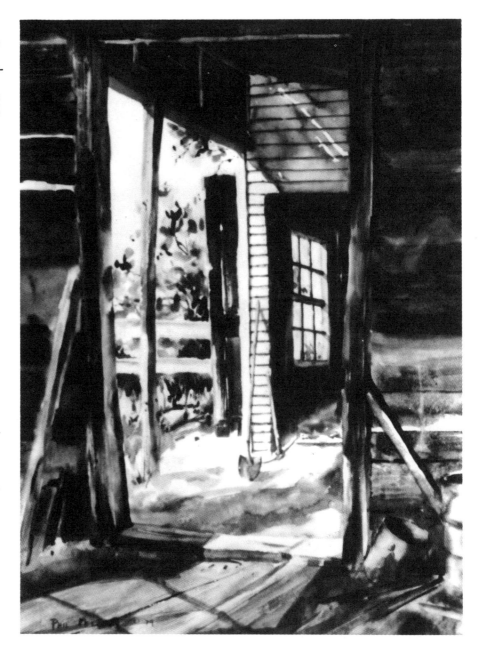

Inside-Out, Phil Metzger, watercolor, 36″ × 28″

change (warm colors up close, cools in the distance), but of course that gets lost in this black-and-white reproduction.
- *Overlap*: the far walls are overlapped by the nearest wall; the support post is in front of the fence, and the fence is in front of the bushes; even the shovel leaning against a wall helps to push that wall back.
- *Blurred edges*: the focus is on the area where the shovel is. The nearest area is somewhat blurred, as are the distant bushes.

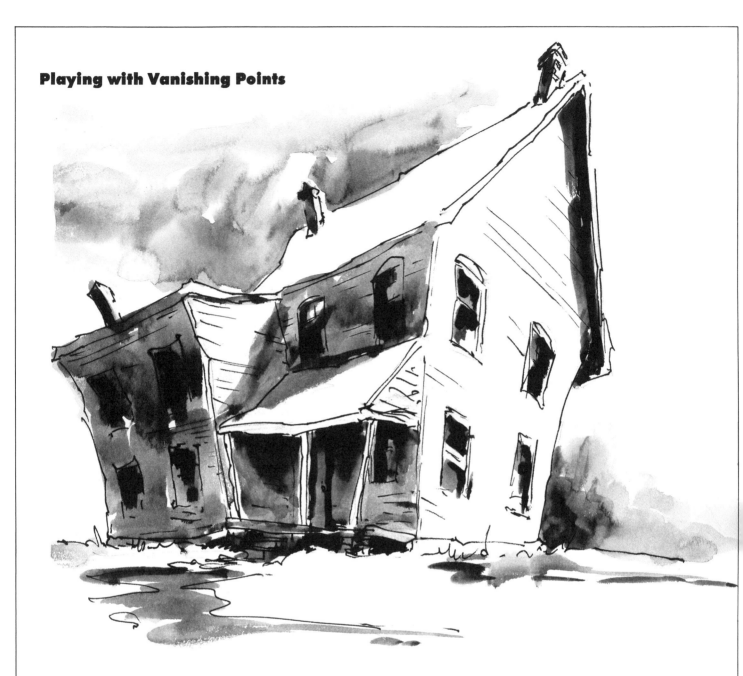

Achieving Distortion

Rotating an object and using its new vanishing points to check up on whether you drew the rotated object correctly is fairly straightforward. There is another way you can fiddle with the vanishing points: you can squeeze them too close together or separate them too widely in order to distort the object you're drawing. The law allows you to do that.

You've probably seen book or maga- zine illustrations in which a haunted house is shown distorted something like the one **above**. In perspective terms, the artist has moved the vanishing points close together to get this effect. In truth, of course, the artist probably does not even consciously consider vanishing points when doing a drawing like this, but he or she is certainly making use of the logic of linear perspective to make the drawing work.

Playing with Vanishing Points

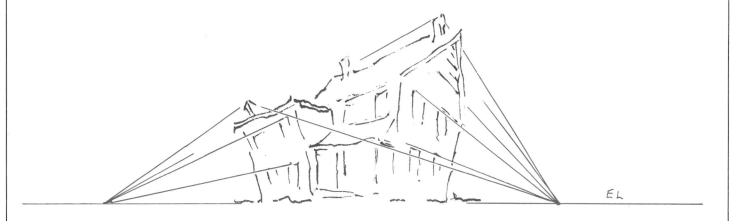

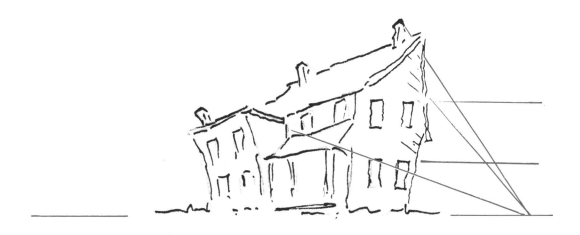

The sketch of the haunted house at **top** shows how the drawing on the previous page used linear perspective. Even though the vanishing points are closer together than in reality, I was careful to make sure all horizontal lines pointed to the same two VPs.

In the second sketch I've drawn the same haunted house without being consistent with the distortions. I've neglected to slant the right-hand windows toward VPR. The result is clearly not right. Consistency is a necessary element of any drawing, even a distorted one.

You can try some distortion easily. Take any picture you have handy of a normal house, trace it off roughly, and on the traced drawing locate the eye level and the vanishing points. Then use the same eye level but move the vanishing points very close together and redraw the house. Always keep in mind that if you're going to distort something, there

should be some point to the distortion, such as creating a particular mood.

There is no absolutely "correct" placement for a pair of vanishing points. You could use all the fancy geometry in the world to get something drawn just right, with the VPs exactly where they belong, and yet find that the object simply does not feel right in your picture. When that happens, be sure the problem isn't elsewhere in the picture—maybe the barn is perfect but the surrounding landscape is drawn poorly, for instance.

But then take a look at that perfect barn and use your good sense and judgment to make a little change here, another there, until you're happy with the result. The result may not be in perfect linear perspective, but that's okay. Notice that in my distorted house lots of perspective lines wobble on their journeys to their vanishing points; some miss by quite a lot. All that matters in the end is that the picture feels right to you, re-

gardless of how it got there. I've seen some perfectly drawn buildings and still lifes (more than a few of them my own) that didn't work because they were too accurate, too "right," too without personality.

I remember some pictures in one of my classes of what were supposed to be tumble-down barns that were done in such perfect perspective that they looked brand-new. The point is, use the "rules" of perspective to give the structure a plausible foundation, observe what has happened to this object over years of wear to hammer it out of its original perfect shape, and then draw what you observe. Just knowing what an original, perfect structure would be like will allow you to take artistic license in a more informed and effective way. This notion applies to whatever you want to draw—people, plants, animals, anything.

Exercise: **Playing with Vanishing Points**

Here are several boxes, each with an eye
level indicated. Locate roughly where
their vanishing points are by extending
appropriate lines to meet the eye level.
Then, in each case, move the vanishing
points in closer to the objects and redraw
them.

EYE LEVEL

EL

EL

Getting the Angles Right

Drawing things convincingly in linear perspective involves constant attention to the angles at which various lines meet each other. Unless you're taking a head-on view of something, you won't usually be dealing with nice, neat right angles (that is, angles where one line is perpendicular to another).

Look at this simple file drawer in two-point perspective. In reality, all the angles shown (*a*, *b*, *c*, etc.) would measure the same if this were a well-constructed box. They'd all be 90 degrees. But because the box is shown in perspective, they're all different from 90 degrees. In fact, they're all different from each other. (Angle *a* is 79 degrees, *b* is 104 degrees, *c* is 113 degrees, *d* is 66 degrees, and so on.) If you don't believe me, you can use a protractor to check up on me and carefully measure each angle. But really, it doesn't matter how many degrees there are in any of these angles. All we want is to get the thing looking right on paper. How do you manage this, short of hiring Euclid?

Let's assume you're entranced by a lovely old Victorian house sitting on a hill. The house has all kinds of angles and curves and even a six-sided turret on one end. You're anxious to get into all the fancy gingerbread trim, but the first thing you need to do is decide from which vantage point you'll do this drawing. Once you've walked around the house and studied it and decided which view is best for your purposes, you stop, set up your easel, and stare morosely at a blank piece of paper. Maybe you do a couple of small thumbnail sketches to decide on the placement of the main shapes on the page and to decide what sort of lighting you

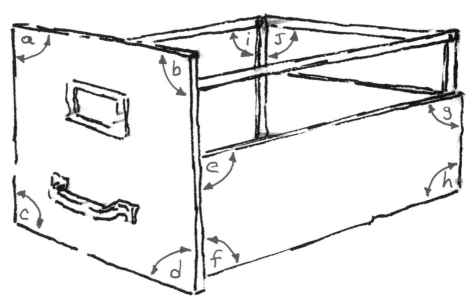

want—will you accept the light and shadow you see now or will you arbitrarily change it? You make some notes to remind you of your decisions so that later, when the sun has aggravated you by moving on, you'll remember what you decided to do.

Once you've decided on the placement of the main shapes in your picture (the house, the hill it's on, some trees, a path or roadway, the sky, the foreground, etc.) you probably very lightly and only roughly indicate these shapes on the page. Very few people can start right in with definite, finished drawing on one part of the page and get to the opposite side of the paper without having run out of room or having too much paper left over.

About eight cups of coffee later you're ready for some real drawing. You make some tentative pencil lines describing the walls and the roof, and quickly find that things are not meeting at the proper angles. The roof slants more than you thought possible. Better check up on it, but how?

Suppose there were a vertical sheet of glass standing at arm's length before you, between you and the house, somehow secure against falling over. If you were to stand in one spot and draw on that glass (with a grease pencil, for instance) you could draw the entire house by "tracing" it on the glass. You would simply copy each line of the house, as seen through the glass, and the result would be perfectly accurate.

Getting the Angles Right

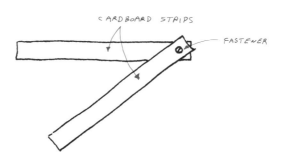

CARDBOARD STRIPS

FASTENER

It's not practical to lug around a sheet of glass, and besides, you want your drawing on paper, so what to do?

Get out your wonderful scientific angle-measuring scissors device, which you made in Part One. Remember? It looks like the drawing at **right**.

Now imagine that you have a sheet of glass standing vertically before you. Hold the angle measurer out at arm's length flat against the "glass," as shown **below**.

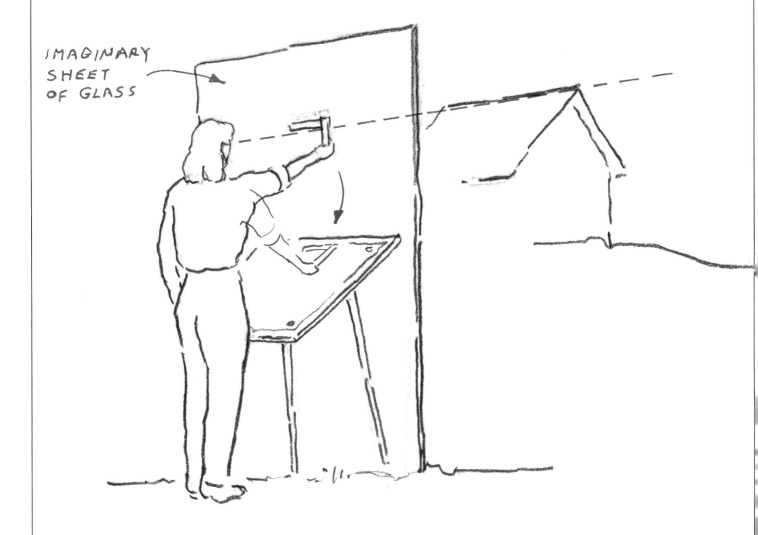

IMAGINARY
SHEET
OF GLASS

Getting the Angles Right

With your free hand arrange the two arms of the measurer so that, still pressed flat against the imaginary glass, they coincide with some angle in which you're interested—perhaps the angle the main roofline makes with any vertical edge of the house or with the vertical edge of your paper, as shown at **right**.

When you get the angle right, carefully move the measurer to the appropriate spot on your drawing paper, position the vertical part of the measurer so that it's parallel to a vertical edge of your paper, and mark the angle, **below**.

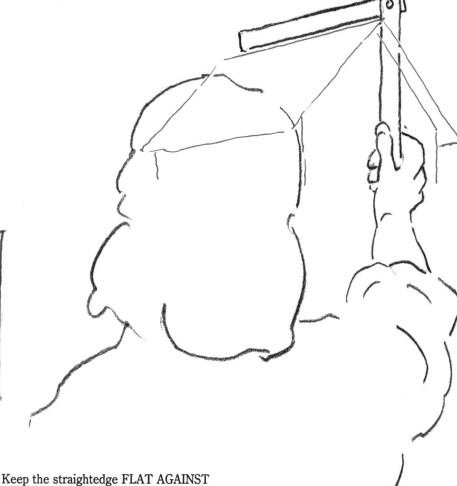

Another Way

There's an even simpler method of getting an angle right, a method we touched on earlier. Although it may be a bit more error-prone than using the cardboard scissors, it's used by practically every artist. Instead of actually getting the angle between two lines, just get the slope of each line separately. If you do this accurately enough, the two lines you get on your paper will meet at the same angle as the two lines on the distant object you're drawing. Simply hold a straightedge (pencil, brush, ruler) at arm's length in the direction of one of the lines whose slope you want to determine.

Keep the straightedge FLAT AGAINST AN IMAGINARY SHEET OF GLASS PLACED BETWEEN YOU AND THE OBJECT, just as though you were using the cardboard scissors. Tilt the straightedge until it matches the slope of the line you're after. Carefully move the straightedge to your actual drawing paper, maintaining this tilt. Don't twist your wrist or bend your elbow along the way. Where the straightedge comes to rest on your paper, you have the slope you're after. Repeat for the other lines whose slopes you need. The trick here is to avoid twisting the straightedge as you lower it to your paper.

Exercise: **Getting the Angles Right**

Find a window that looks out on some buildings or other objects and draw on the window using grease pencil or any removable paint. Once you get set, with your feet firmly planted and your head in a particular position, don't move up or down or sideways; if you do, you'll change what you're seeing through the glass. If you have a door inside the house or studio containing panes of glass, use it to do an interior drawing. You can swing the door so that you can focus on any part of the room beyond, then block the door to keep it from swinging, and go ahead and draw. You can even drive your car to an appropriate scene and draw on its windows! In any case, you'll reproduce a scene that's very accurate, angles and all. You're using windows as you would a piece of tracing paper. In fact, if you use thin enough tracing paper or clear plastic taped to your window, you won't need to actually mark on the window at all.

The Perspective Center

It's often necessary to locate the center of an object so that you can place something there that you know should be centered—a doorway, perhaps. If the object is shown in perspective, you may still need to know where its center is, but now we're talking about its *perspective center*. Here's how to locate a perspective center.

First, where's the actual center of the rectangle? How do you find it? If you remember your high school geometry, all you need to do is draw in the rectangle's diagonals, and wherever they meet, that's the center.

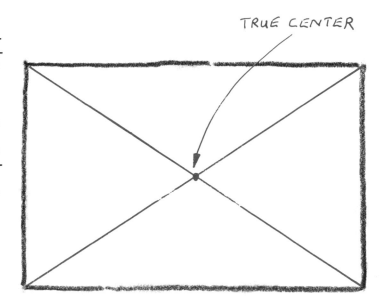

Suppose the rectangle is tilted away from you—that is, thrown into perspective. *Now* where's its center? Or, to frame the question more precisely, where is the perspective center? Same answer as before: Draw in the diagonals, and where they meet is the perspective center.

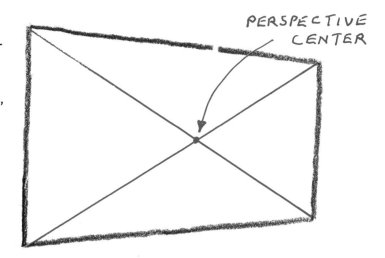

Using the Perspective Center

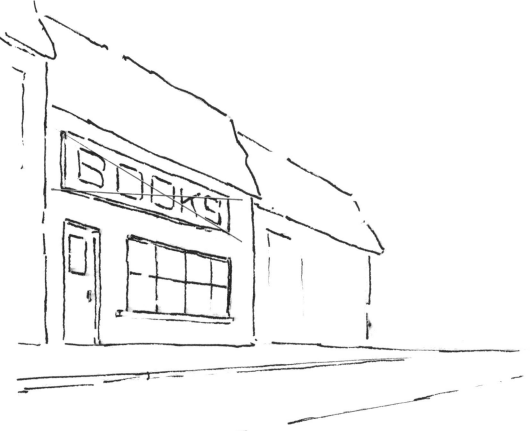

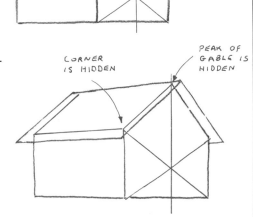

Let's say you want to draw a storefront and its sign in perspective and have the letters on the sign appear in proper perspective. You might find the "center" of the sign by crossing diagonals, sketch in the middle letter at the perspective center, and distribute the other letters to the left and right of that letter, with letters that are closer to you farther apart than those away from you, **above**.

Or suppose you want to find the middle of the end of a house in perspective so that you can properly place the peak of the house. For simplicity, we'll use a Monopoly game house with no overlapping roof or other distractions. At **top right** is how the house might appear looking at it straight on.

Now if we turn the house so that we're seeing it in two-point perspective, **center right**, the perspective center line is no longer halfway between the two edges of the house; you can't locate it by measuring with a ruler. To place the per-

spective center line, all you need do is draw in the diagonals of the end of the house (ignoring the triangular portion, or gable, for a moment). Draw a vertical line through the point where the diagonals cross. The peak of the gable will lie along that line.

It would be rare to find a house actually built like the one we've just studied. More often we find the sort of construction shown at **bottom right**. In this view the peak of the gable is hidden under the roof. So is one of the corners to which you would draw your diagonals. When drawing such a structure, with its hidden corners, rely first on drawing what you see, as always, but when the result doesn't feel quite right, go back and do a little construction. Lightly sketch in the end of the house as it would appear without the overhanging roof. Then add the roof. An exercise later in Part Two will explore this idea further as you build a house from scratch.

Exercise: **Using the Perspective Center**

In these figures the "centers" of the gabled ends have been located incorrectly. To shape the gable correctly, start by drawing diagonals to locate the perspective center. Then extend the roofline and draw a vertical line through the perspective center to meet that line. From there, you should be able to draw the correct gable.

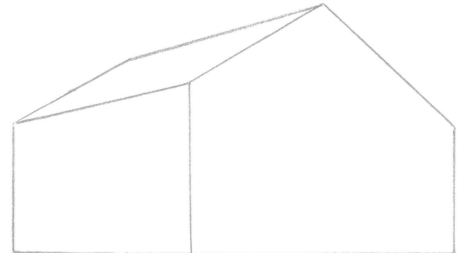

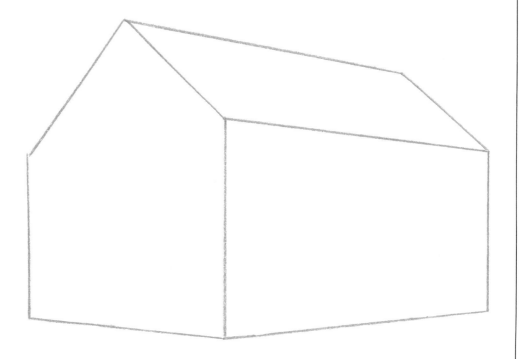

Using the Perspective Center

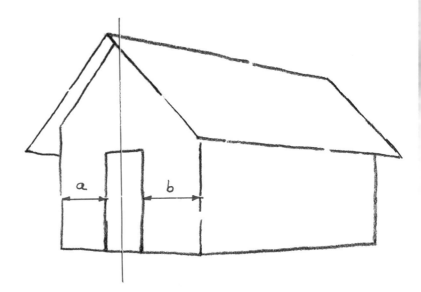

Locating a Door or Window

There are a number of ways you can add a doorway to the gabled end of a house, and I'll show you one method here. But first let's start with a finished doorway and make some observations about it so that in the construction steps you'll know what we're aiming for.

Notice first that in the head-on view, **above**, with everything neatly centered, distance *a* equals distance *b*. Second, there is as much doorway to the left of the center line as there is to the right. No surprises there.

In the perspective view, however, distance *b* is greater than *a*, and there is more of the doorway to the right of the perspective center line than to the left. Everything seems to squeeze smaller as it goes away from the viewer into the distance. Notice, too, that the top and bottom of the doorway, which are simple horizontal lines in the head-on view, slant toward the left vanishing point in the perspective view. These are things to look for constantly in your drawing. Again, draw what you see, but when you get in trouble do some basic construction (sometimes on your paper, sometimes only in your head) to get things right.

Using the Perspective Center

Let's see how we might actually construct a doorway in the perspective center of a wall. We'll start with a wall whose perspective center line we've already found. The top level of the doorway is already indicated.

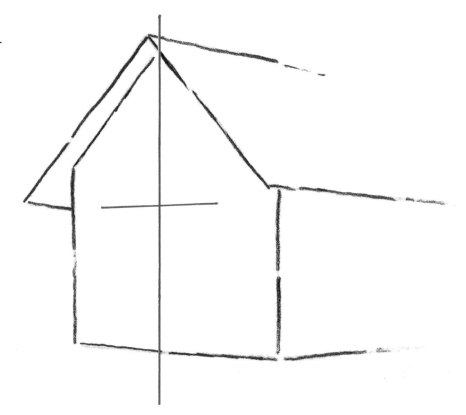

The easiest way to proceed (there are other ways involving more geometry) is to estimate where you want one of the vertical sides of the doorway and draw it in. Here I've put in the right-hand side.

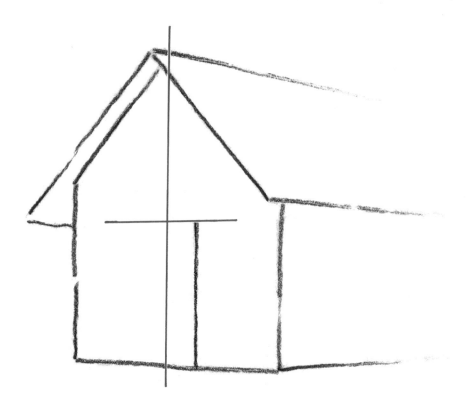

Using the Perspective Center

What I would really do next is simply draw in the left-hand edge a little closer to the perspective center line than I drew the right-hand edge. But to get it where it belongs through construction, mark the center of the height of the doorway. Measure between the top and bottom of the doorway with a ruler, or just eyeball it. For practical purposes, this will be the perspective center of the doorway.

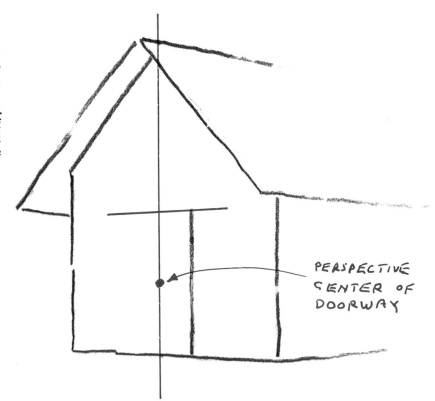

PERSPECTIVE
CENTER OF
DOORWAY

Now draw one of the diagonals of the doorway by drawing a line from one of the corners through the perspective center. I've drawn the one going from lower right to upper left.

Using the Perspective Center

Draw a vertical line through the point where the diagonal hits the upper edge of the doorway. The doorway is now outlined in proper perspective.

The important thing to observe in a drawing such as the one at **right** is the squeezing down of various dimensions as they recede farther from the viewer. You can always get a quick fix on where to place objects such as doors and windows if you locate the perspective center first by crossing a couple of diagonals. If you're placing objects that are not centered, but are equally spaced in a wall (such as a row of windows), it's still helpful to locate the perspective center and then, using good old eyeballing, place the objects to either side of that center, as I've done here.

Notice that I've done three things to enhance the feeling of depth: (1) the windows get progressively smaller; (2) the spaces between them get progressively smaller; and (3) the space to the left of the nearest window is greater than the space to the right of the far window.

Remember, the building you are drawing may not be constructed with such neat symmetry. Many aren't, of course, and therein may lie their particular charm. Still, if you understand the basics of what happens in a symmetrical structure, you can extend that knowledge to figure out what's happening in less orderly situations.

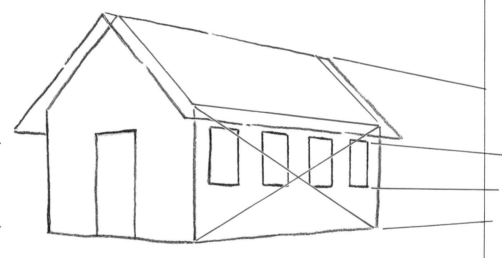

Troubleshooting

Suppose you're drawing a scene in which there are several buildings of differing sizes situated at various distances and angles from the viewer. You've drawn everything in proper linear perspective, but the scene seems too static. Things are lined up too neatly. Your eyelids are becoming heavy and you know something is wrong. So you disrupt your static scene and turn a building at an angle different from what you actually see. What are you really doing when you twist that building at a new angle? You're relocating its vanishing points.

Here's a sketch in which I don't like the position of the table because I can see the same amount of the left side as of the right. Things divided exactly in half can be boring.

So I mentally rotate the table a little, and try to create more visual interest. Whenever you rotate an object like this, what you're really doing is changing its vanishing points. As you can see, I've left the eye level the same and haven't changed the table's height or other characteristics. But clearly, I goofed. Something's not right. This will often happen, but it won't always be obvious what is not right.

Troubleshooting

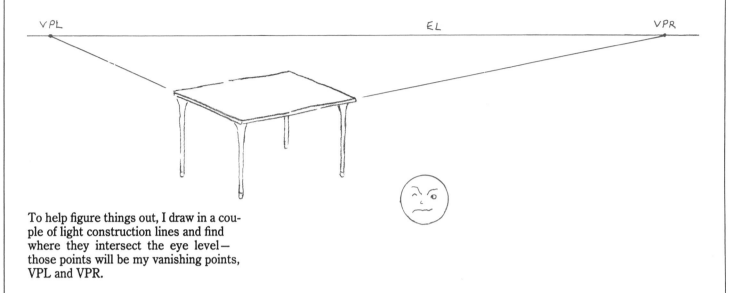

To help figure things out, I draw in a couple of light construction lines and find where they intersect the eye level—those points will be my vanishing points, VPL and VPR.

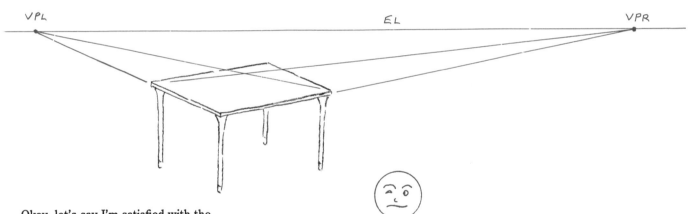

Okay, let's say I'm satisfied with the angle the construction lines make where they meet at the front corner of the table. (If I'm not satisfied, I'll have to start again, which really means moving the vanishing points so that the lines meet at the corner of the table at an angle that feels right.) Now I want to see whether I've drawn the rest of the table consistent with the part I like. I draw in a couple more construction lines and see that the rear edges of my tabletop are pretty sloppy.

Troubleshooting

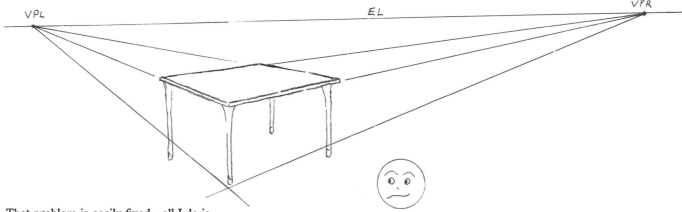

That problem is easily fixed—all I do is make the table edges conform to the construction lines.

Now I wonder about the legs. On an ordinary four-legged table, you would expect the legs to act as though they were the edges of a box, wouldn't you? So I draw in two more construction lines and find that my legs aren't quite right.

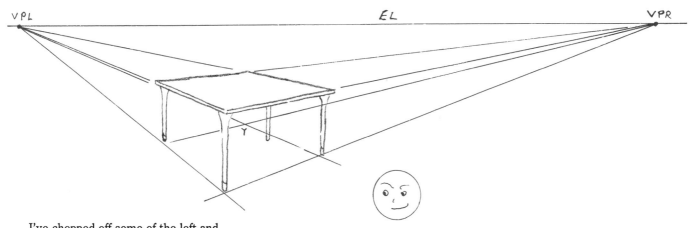

I've chopped off some of the left and right legs to make them conform to the construction lines. So far, so good, but the rear leg still doesn't seem right. To place it I draw in two more construction lines and where they meet (at Y) should be where the rear leg goes.

Troubleshooting

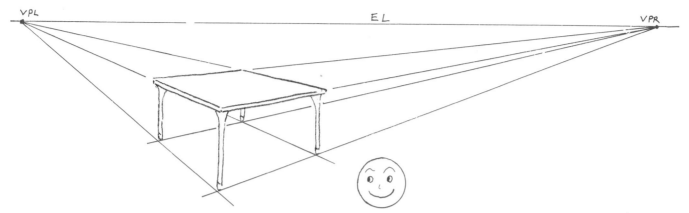

I've moved the rear leg to its new position, and finally my table looks decent. Trace this table and overlay it on the original one (reprinted below) to see the effect of the changes wrought by a little fiddling with perspective.

EL

Placing Doors and Windows

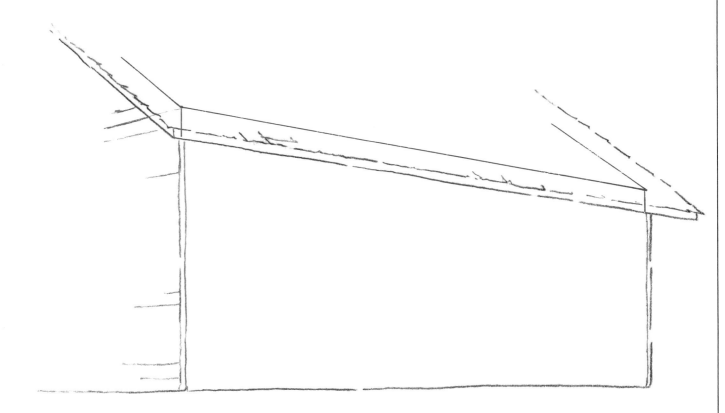

Following the steps outlined at **right**, place a doorway and two window openings in the long side of this house. I've indicated the lines of the roof beneath the overhang to make it easier.

Step 1: Draw in the diagonals of the side of the house and locate the perspective center.

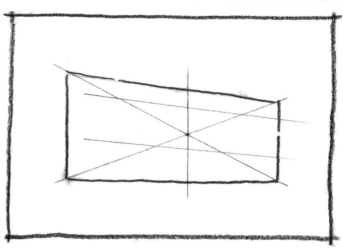

Step 2: Draw a light construction line representing the tops of the door and windows. It should slant toward the right-hand vanishing point. Draw a similar line to represent the bottom edges of the windows.

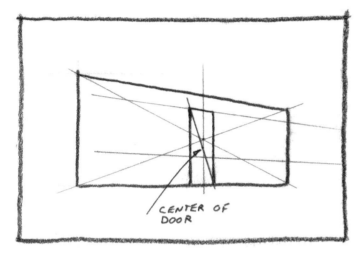

Step 3: Draw in the doorway using the method described in the text.

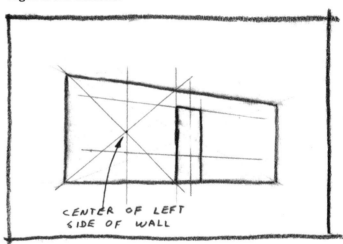

Step 4: Locate the perspective center of the portion of the wall to the left of the doorway.

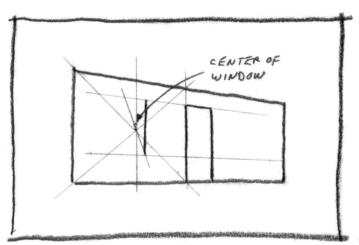

Step 5: Draw a vertical line where you want one side (I've shown the right side) of the window to be. Draw the window's diagonal.

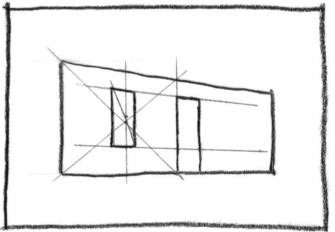

Step 6: Where the diagonal intersects the top of the window, draw a vertical line. This is the other side of the window. This is the same method used earlier to construct the door. Now locate the perspective center of the portion of the wall to the right of the doorway and construct the right-hand window exactly as you did the left. If you feel like experimenting further, try constructing a small window in the door.

Boxes Within Boxes

Many of the subjects of your drawings and paintings may be complex-looking buildings, vehicles, machinery, furniture, and so on. But most of them are not as complex as you might think. Often they are combinations of boxes in perspective tacked onto other boxes in perspective. If you visualize them in that way, the job of drawing becomes a lot easier. Here are some examples of boxes within boxes, exploded to illustrate that each part taken by itself is quite simple. The first is my desk, which normally does look as though it had exploded, **below**.

As an exercise, look around you for some common items, such as bookshelves, cabinets, computers, toys, houses, chairs, and so on, and try draw-

ing them in "exploded" fashion. Don't worry about a fussy, technically accurate rendering—just see if you can mentally break an object into a set of more or less rectangular pieces and draw them in rough linear perspective. The more you practice this exercise, the better feel you'll get for the volume and hidden edges of things.

In discussions up to now I've talked about such things as "doorways" rather than "doors" and "window openings" rather than "windows." That's because I didn't want to confuse the drawings by becoming concerned with the thicknesses of those objects. A doorway can be thought of as an opening with no thickness, but a door is a chunk of stuff

that does have thickness. In the exploded house on the next page I've shown the thickness of some parts of the house to emphasize that they are mostly boxes—thin ones, maybe, but boxes nonetheless—and like any box they are subject to the "rules" of linear perspective. Notice, for instance, that the windows are boxes, or slabs, each having its own slanting perspective lines.

What gets interesting is the way objects connect. When two boxes connect at right angles—the chimney against the side of the house, for example—their connection is defined by a straight line. That's easy. But where slanted surfaces such as roofs join, their intersection will often be some crazily slanted line.

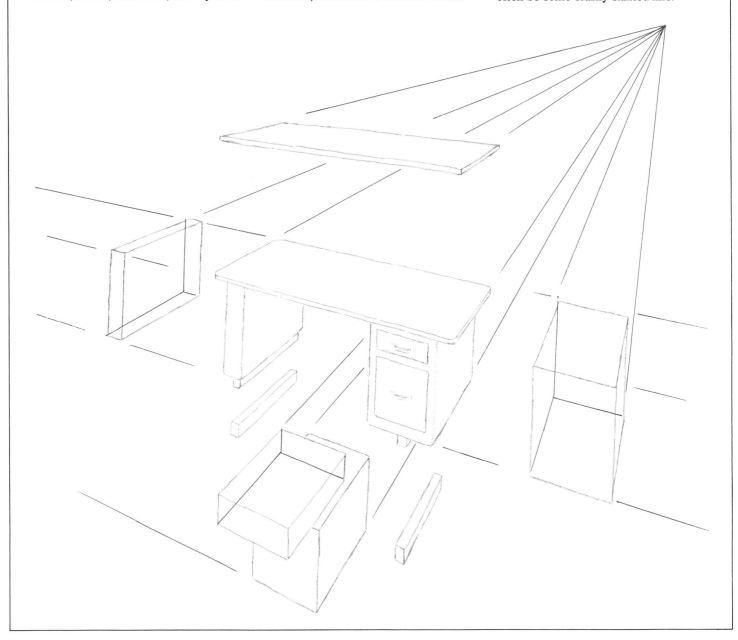

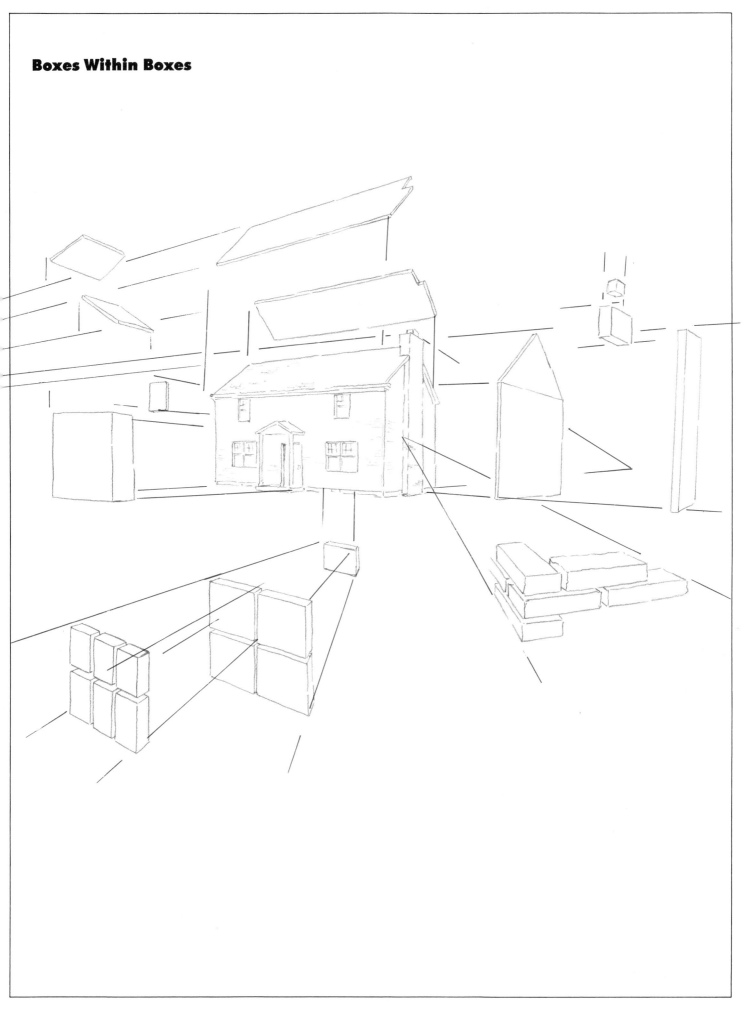

Building a Glass House

The following exercise will lead you through the construction of a house. It's a simple one, but its construction nonetheless can become quite involved, so please follow the exercise steps carefully. Once you've mastered this exercise, you'll be able to tackle practically any rectangular shape in two-point perspective.

I suggest you start by glancing at the entire set of steps I've laid out beginning on page 75 and then go back to the beginning and build the house along with me, using the practice areas on pages 72-73. Think of the house as transparent so that you can see all its edges and corners. Use light pencil lines or colored pencil for construction lines and darker pencil for emphasizing certain areas to help you to visualize the emerging structure. You might erase construction lines when you no longer need them, but don't be too hasty; sometimes you'll wish you still had an earlier line to help guide you.

When you're finished, you might want to give your stark-looking house more reality by giving the roof some thickness and adding details such as drainpipes, windowpanes, and so on.

There is room on the exercise sheet for a number of tries at this drawing. I suggest you first do one exactly as I have (I've placed a couple of starting lines and the vanishing points for you). Then fol-

low all the same steps but do a different building—one of different size, or one oriented farther above or below the eye level, for example. Depending on where you place your house, be prepared for some strange things to happen. For instance, if you view a house that is *high* enough above your eye level, you'll see nothing of the exposed surface of the roof; all you'll see is the edge of the side of the roof nearest you and a bit of the underside of the part of the roof away from you. If you're looking sharply *down* at a house, however, you might see little other than its roof.

EYE LEVEL

Building a Glass House

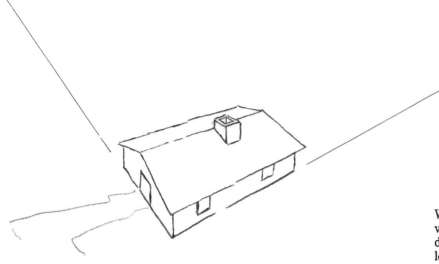

When drawing a house from a very high viewpoint, you'll get a very different drawing than you would from ground level or from below it. Experiment with different eye levels and angles to explore effects like these.

71

Exercise: **Building a Glass House**

VP_L

a

VPR

Follow step-by-step instructions beginning on page 75.

Exercise: **Building a Glass House**

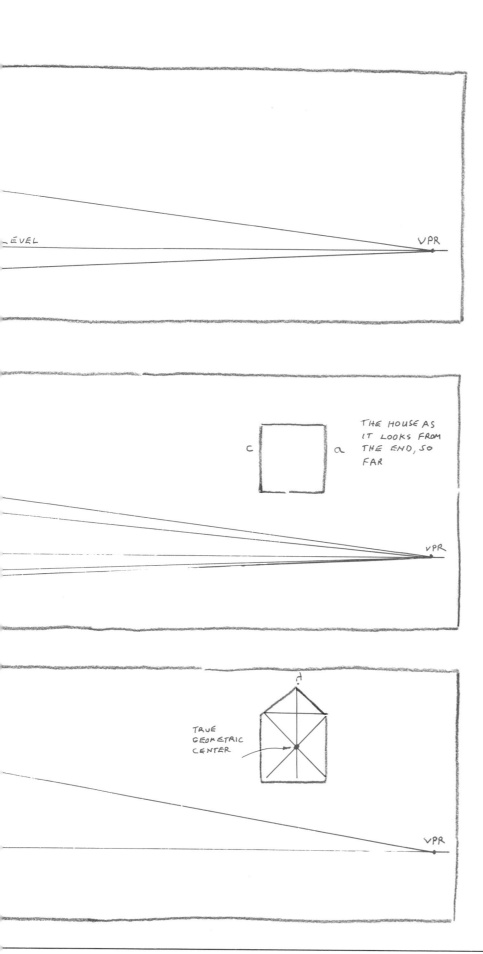

Stage One

Step 1: Establish the eye level.

Step 2: Draw the nearest vertical edge, *a*.

Step 3: Select the left and right vanishing points, VPL and VPR. I've placed them close enough to the building to keep them on the drawing paper.

Step 4: Connect the top and bottom of *a* to both VPs.

Step 5: Decide on the length of the right side of the house and draw vertical edge *b*. Do the same on the left and draw edge *c*. Two walls of the house are now established.

Stage Two

Step 1: Now find the right (hidden) end of the house. Connect the top and bottom of vertical edge *c* to VPR; connect the top and bottom of vertical edge *b* to VPL.

Step 2: Where those lines cross, at X and at Y, draw vertical (hidden) edge *d*.

Step 3: With the flat of the pencil, or with colored pencil, lightly shade in the house ends to help visualize the structure.

Stage Three

Step 1: Establish the gables (the triangular ends) of the house. Begin by locating the perspective center of the left end of the house. Draw the diagonals; where they cross is the perspective center.

Step 2: Draw a vertical line through the perspective center.

Step 3: Repeat steps 1 and 2 for the right-hand end of the house.

Step 4: Decide how high you want the peak of the roof to be. Mark off this height at H.

Step 5: Draw a line through H and VPR. This gives you the slope of the ridge of the roof. Intersection J is the height of the right-hand gable.

Step 6: Complete the left gable (the triangle) by drawing *e* and *f*. Complete the right gable similarly. Shade them in.

Exercise: **Building a Glass House**

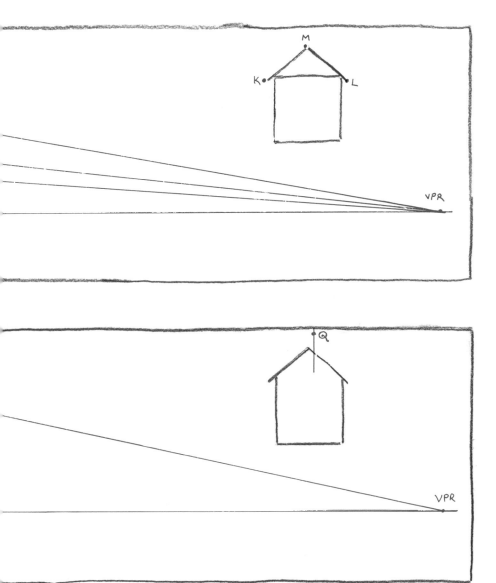

Stage Four

Step 1: Install the roof cap. First decide how far you want the roof to extend beyond the left end of the building and mark off that length at M.

Step 2: Draw a line through point M parallel to *f.* This is the far-side overhang.

Step 3: Decide how far down toward the ground you want that overhang to go and mark it, point K. Connect K to VPR.

Step 4: Draw a line through point M downward to the right, parallel to *e.*

Step 5: Draw a line from VPL through point K and extend it toward the right. This intersects the last line you drew at point L.

Step 6: Connect L to VPR. You now have the near-side overhang.

Step 7: Look at the distance between points M and H. Mark off that same distance (or slightly shorter) from point J toward the right at N. Draw a line through point N parallel to *g.* Where this line intersects the last line you drew, at P, is the final corner of the visible roof.

Step 8: If you wish, darken in the slab of roof (MLPN) facing you. Blacken in much darker the underside of the left overhang.

Stage Five

Step 1: Install a chimney. Think of the chimney as another smaller rectangular box in perspective, perched atop the roof. First draw a vertical line representing the nearest vertical edge of the chimney.

Step 2: Decide how high the chimney is to be, point Q.

Step 3: Draw lines through Q to both vanishing points.

Exercise: **Building a Glass House**

Stage Six

Step 1: Decide how thick each face of the chimney is to be and draw two vertical lines.

Step 2: Let's say this chimney is to be totally on the near side of the roof, as shown in the inset.

Step 3: Draw a line from point R down the slope of the roof parallel to the front edge of the roof.

Step 4: Draw a line from intersection S toward VPR. You now have your chimney. Darken in the front and side surfaces, one darker than the other, to help show some form.

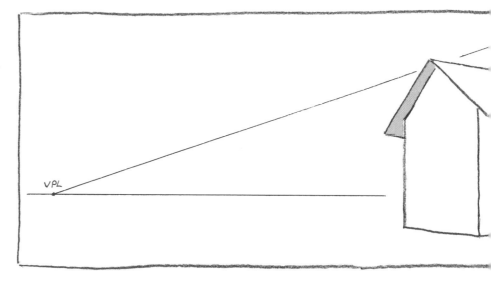

Stage Seven

Step 1: Install a door in the left end of the house. First, draw a line from VPL through the end of the house to show the height the doorway is to have.

Step 2: Draw two vertical lines, *r* and *s*, on either side of perspective center to show the width of the doorway. Don't forget that more of the doorway should show to the right than to the left.

Step 3: To show the *thickness* of the doorway and the door itself set back into the wall, draw a short construction line from point T toward VPR.

Step 4: Draw vertical line *w* (see the inset) to show the doorway thickness (whatever thickness you wish). Draw line *y* to show the thickness of the upper edge of the doorway (this line should connect to VPL). Darken in the recessed edges.

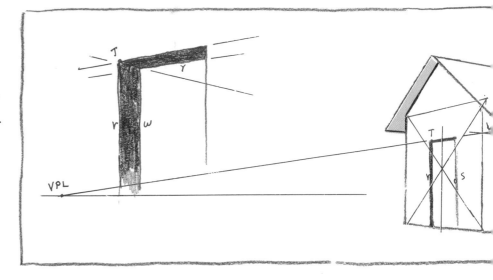

Step 5: Install a pair of windows in the long side of the house. First establish a height for the tops of the windows. It's often the same as the height of the door, so draw a line from point V toward VPR. You now have the tops of the window openings.

Step 6: Decide how low you want the bottom of the window openings to be and draw a line from VPR to represent that height.

Step 7: Now draw four vertical lines rep-

resenting the sides of the window openings. Put them where you want them.

Step 8: Give the windows depth the way you did the doorway. Shade the recessed surfaces. See the inset for a little more detail.

Step 9: Erase construction lines and add anything you wish, such as more windows or a second chimney.

Step 10: If you got it all right, help yourself to the pie!

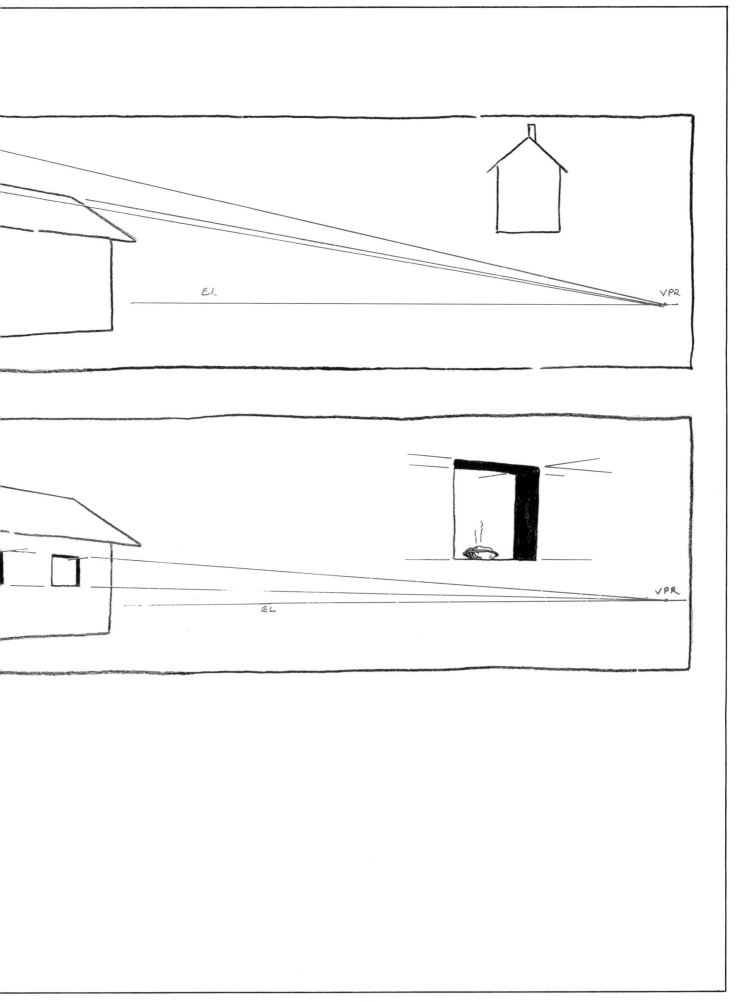

Collections

Suppose you're drawing a collection of objects, such as the buildings in a village or the various items in a still life, and you want to draw them just as you see them. The first thing you must do is decide the position from which you want to do your drawing. Remember, a scene drawn or photographed by two people standing even just a short distance apart will be different in the two renderings. The same is true if there is only one observer who simply can't decide whether to stand or sit while making the drawing. You've got to decide on your viewing position and stick with it. This is particularly true concerning the viewer's eye level. Any change in your eye level affects what you're seeing.

Once you've established the eye level from which you're going to draw the scene, draw a light horizontal line across your paper to indicate where the eye level in the drawing is going to be. Now go ahead and draw, constantly relating everything to the eye level line you've established on your paper. If there's a house down in the valley below your eye level, it'll be placed on the paper below that eye level line, and there will be lines in that building slanting UP toward the eye level line. If there is a building on a hilltop in this same scene, it will be somewhere on your paper above the eye level line and it will have lines slanting DOWN toward the eye level line.

What about the vanishing points for all the buildings scattered throughout your scene? Each building will have its own set of vanishing points, but they will ALL lie along the same eye level line. Depending on how the buildings are situated, some of their vanishing points may coincide. Some, such as the house in the final exercise, may have only a single vanishing point. That's one-point linear perspective, discussed in Part One. I've included the house in one-point in order to calm the scene a bit. If all the objects in a scene are rendered in two-point, there may be a feeling of disarray. The house in one-point provides a resting place for the eye.

Exercise: Collections

Gather several boxes and pretend they are buildings. Place some on a low coffee table, some on the floor, and some on a higher table. Sit so that your eye level is anywhere between the highest box and the lowest. Sketch the assortment of boxes after first deciding on an eye level. Carefully determine the vanishing points for each. All vanishing points should fall on the same eye level line, of course, but some may fall far out of the picture—in fact, far out of the room—and will need to be imagined. Note that you can make a vanishing point fall closer to the object by turning the object at a different angle to your line of sight. If you place one of the boxes directly in front of you and you're seeing its face flat-on, there will be only a single vanishing point and all you'll draw is a rectangle.

Differing Elevations

Here is a scene in which buildings are sitting at differing elevations. Using a straightedge, determine where the vanishing points are for one building and use that information to draw in the eye level. (You may need to attach extra paper on the right and draw across the text on the left.) Then locate the vanishing points for the other buildings and notice that although quite scattered, they all fall on the same eye level.

Notice this, too: The vanishing points for a couple of objects, such as the broken-down mailbox and the sloping rightmost roof area of the nearest shed, don't fall on the eye level line. The "rules" we've been using apply to objects that are oriented the way normal, sound houses are—floors or bases flat and parallel to the ground, sides vertical. Introduce a building sliding down a muddy California slope and all bets are off. That building won't conform to anybody's rules. If the mailbox in the drawing below were propped upright, as it probably was before some joyrider whacked it, it would obey the rules.

There *are*, however, perfectly legitimate vanishing points that don't land on the eye level. They'll be discussed in Part Three.

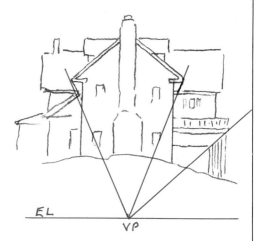

THIS BUILDING IS IN ONE-POINT PERSPECTIVE

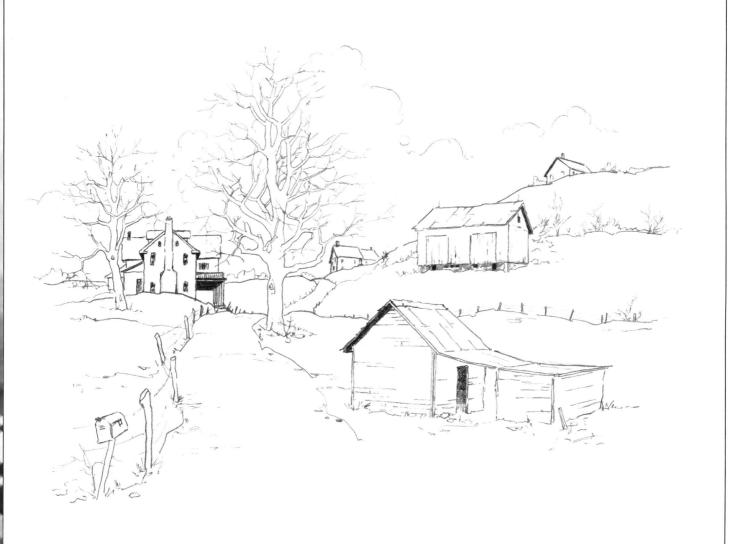

Part Three:
Curves and Inclines

So far in this book, we've dealt mostly with neat blocks, straight lines, and two vanishing points. Happily, there's a lot more variety than that among the things we draw and paint. There are all kinds of curves and inclines, for example, and there are, as astronomer Carl Sagan might say, billions and billions of vanishing points. Such rich variety offers endless possibilities for our art, but does it also bring on endless headaches? How do we approach drawing all those odd shapes in perspective? And how do we deal with multiple vanishing points?

The way to deal with an apparently new problem is to start with the things we already know. We know how to draw rectangular objects in perspective, so it makes sense to try to see a new, odd-shaped object as being roughly rectangular or as being made up of a number of rectangles or parts of rectangles. If an object is curved, we can usually envision it as being placed within a rectangular box, so we draw that box in perspective and "fit" the curved object inside it. As for all those vanishing points, we normally have only two, or at most three, to be concerned with at any one time. Very often we only need to know the general locations of vanishing points and never have to pin them down precisely. As Part Three will demonstrate, you can solve most perspective problems with the tools you already have.

Getting Started

To begin learning how to handle the problems presented by curves in perspective, we'll first address the circle. Drawing circles may seem easy, but when they're seen in perspective, they are transformed into a less well-known relative of the circle, an *ellipse*.

Just what is an ellipse? Although there is a precise mathematical definition of an ellipse, it's easier just to think of it as a squashed-down circle. J.D. Salinger describes a character in one of his stories as having a head that appeared to have been squeezed in a carpenter's vise. That head would be an ellipse.

Ellipses can be fat (almost circular) or thin (almost a straight line) or anywhere in between. There are plenty of objects around that are actually made in an elliptical shape—platters, serving bowls, swimming pools, and so on. Most ellipses we see, however, are really *circles seen in perspective,* and it's those ellipses we're most concerned with here.

Circles and Ellipses

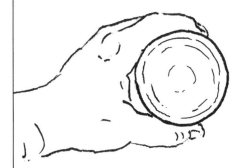

Take a can of beans from the pantry and look at its top. If you view it straight on, it's circular.

But if you view it from the side, the top may look like one of the other two drawings at **left**.

Think of an ellipse this way: it's a circle tilted away from you.

As you snoop around the pantry you'll find elliptical shapes galore. Glance out the window at your car. If it's parked at an angle to you, its wheels and tires will appear elliptical. Look at the top of a lampshade, a phonograph record lying at a distance, a saucer—they're all really circular, but they appear elliptical when viewed from most positions.

Let me repeat: An ellipse is a circle in perspective. If we can figure out how to draw a circle in perspective, we'll end up with an ellipse. To find out how to draw a circle in perspective, we'll go back to a more familiar object, the square. As you probably know, a square is a rectangle with all four sides equal. A circle can always be drawn inside a square, and it will touch the square at the middle of each of its sides. The center of the circle will be at the same point as the center of the square—that is, the place where the square's diagonals cross. **Below left** is a circle drawn inside a square (or, if you prefer, a square drawn around a circle).

Suppose we turn this square slightly away from us, **below right**. The square is now in perspective, its top and bottom edges retreating to some distant vanishing point. But the circle has also taken on a different shape: it's become an ellipse. Draw the diagonals in the figure to locate the square's perspective center, as shown in Part Two. That point is also the perspective center of the ellipse.

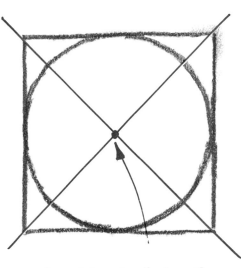

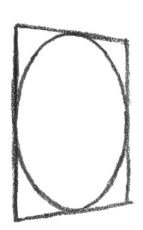

CENTER OF CIRCLE IS CENTER OF SQUARE

Circles and Ellipses

Drawing Ellipses

You can draw ellipses in a variety of ways. Done freehand, they may at first tend to look like the ones at **right**. There are two problems here. The first is that an ellipse never has sharp points any more than a circle does. Keep in mind that at its narrowed "ends" an ellipse is still a curve; it never stops abruptly to change direction, but simply keeps curving around until it has *gradually* changed direction. The horses at an oval racetrack don't stop and change directions; they just keep on leaning and traversing the curved track.

The second thing to remember is that an ellipse is a uniform curve; it's not teardrop-shaped, fatter at one end than at the other.

Most of the time you'll sketch an ellipse without actually sticking it inside a perspective square. But if you're doing some ticklish drawing where you want more accuracy—maybe you're illustrating a piece of machinery, for instance—it may be a good idea to start with the square, with its perspective center located, **right**.

Then mark the perspective center of each side of the square, **far right**.

Now lightly sketch in a curve that touches the perspective square at each of the four points you've marked, and nowhere else. (In mathematics, one would say those four points are where the curve is tangent to the square.) Notice that the curve sweeps smoothly through the four points where it touches the perspective square, rather than change direction abruptly at those points, **right**. It's important to remember those smooth curves so that you avoid drawing curves like the one at **far right**.

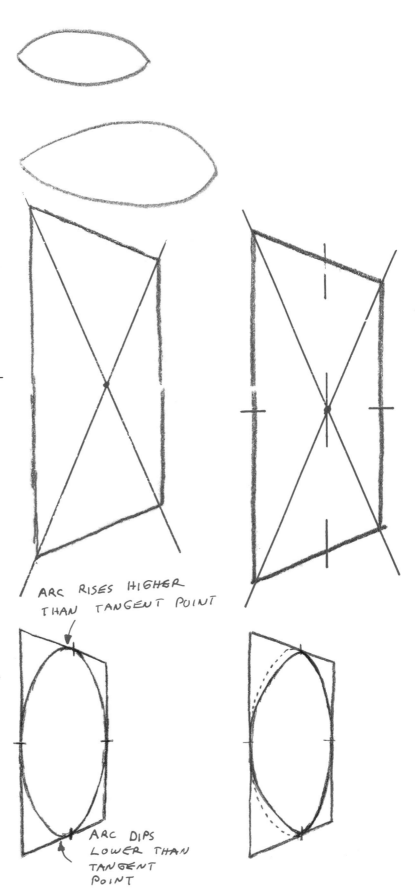

ARC RISES HIGHER THAN TANGENT POINT

ARC DIPS LOWER THAN TANGENT POINT

Exercise: **Getting the Feel of Ellipses**

In this exercise we'll construct some el-
lipses that actually conform to the mathe-
matical definition of an ellipse; however,
we will not get into any of the mathemat-
ics. All I want is for you to understand
the shape of a true ellipse. I'm not pro-
posing you actually construct ellipses in
this manner in your drawings—NEVER!

You'll need two pushpins, a pencil, a
piece of string, and a piece of cardboard.

Step 1: Stick two pushpins into a piece
of cardboard; place them about four
inches apart. Fasten the ends of a piece
of string about six inches long to the two
pushpins. (The easiest way to fasten the
string is to stick the pins right through
it.) Make the string taut by inserting the
tip of a pencil into the loose loop. ·

Step 2: Keeping the string taut with the
pencil, draw a closed curve. Don't worry
about doing this all in one smooth move-
ment—the string will get wound around
the pencil point and you'll have to untan-
gle things once or twice. If you succeed
without pulling the pushpins loose, you'll
end up with a true ellipse.

Now try the same exercise, varying
both the distances between the pushpins
and the length of the string.

Just for your information and intellec-
tual enlightenment, the names of the two
points where the pins are located are the
foci; the long dimension the foci fall on is
the major axis; the line perpendicular to
the major axis and bisecting it is the mi-
nor axis. Now don't you feel smart?

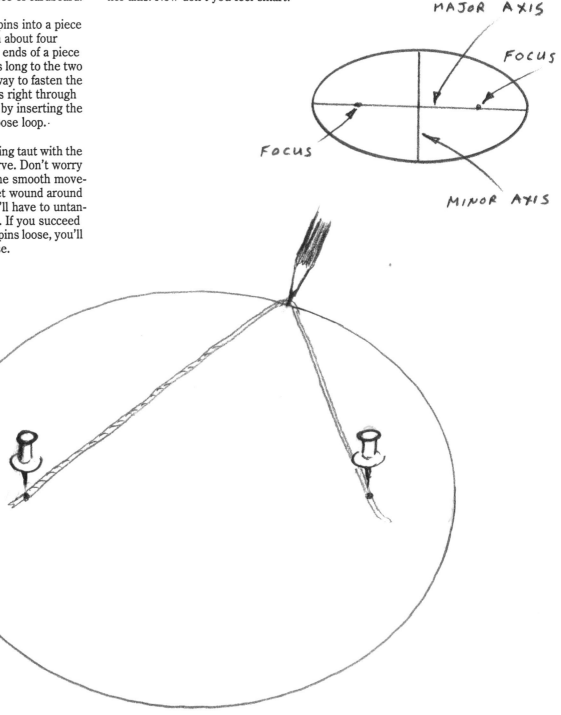

MAJOR AXIS

FOCUS

FOCUS

MINOR AXIS

86

Exercise: **Getting the Curves Right**

Here are two squares in perspective. In both I have indicated the points at which an inscribed ellipse should touch the sides. In the first I've already drawn an ellipse freehand, which looks reasonable. Notice that it only touches the square at the left and right tangent points. Notice, too, that after touching the square at the left and right tangent points, the curve curves even wider before gradually changing its direction. The widest dimension of the ellipse is not at the tangent points.

Trace over the curve to get the feel of how it travels. Then draw a similar curve in the remaining perspective square.

Hint on drawing curves: For most people, it's easiest to draw a curve that curves away from one's body. To do so, draw part of the curve and then rotate the paper to draw the next portion. A couple of rotations later the curve will be closed.

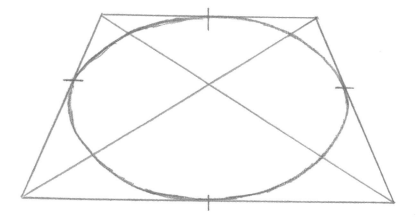

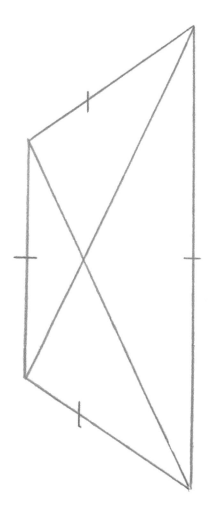

Exercise: **Drawing Ellipses in Boxes**

Here are some squares in perspective. Practice making ellipses (circles in perspective) by inscribing an ellipse in each "square." Some of the squares already have their diagonals drawn, some have tangent points shown. Remember, the curve of the ellipse touches the sides of the square only at those tangent points. Be sure your curves sweep gracefully through the tangent points rather than abruptly change direction at those points.

Circular Objects

We're not often concerned with drawing simple, flat circles in perspective. What we're generally concerned with is drawing three-dimensional objects whose cross sections are circular—objects such as bottles, columns, silos, and trees. Let's see how what we've learned about ellipses applies to these objects.

The Importance of Eye Level

Before we begin, though, let me repeat one important piece of advice. In Parts One and Two, I stressed the importance of establishing the eye level in a picture before doing any drawing. This admonition applies not only to rectangular objects, but to circular and other curved objects as well. Failure to nail down the eye level is one of the most common errors in painting and drawing.

In countless still lifes I've seen weird vases like the one at **right**. The top of the vase suggests that the eye level in the picture is somewhere above it. But the flattened bottom insists that the eye level is even with the bottom of the vase. It may be that the still life painter was imitating a famous artist who used distortion to make a point. By all means, distort things if you will, but be sure you're doing it on purpose.

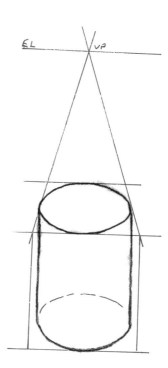

Now let's go back to the pantry and get out that can of beans. Instead of viewing only its ends as circles inside squares, let's see the entire can as a cylinder encased in a rectangular box, **right**.

I've included only enough construction lines to suggest the box; as an exercise you may want to fill in the hidden edges of the box. It's important to notice that the bottom of the can, the end farthest from your eye level, shows up as a slightly fatter (rounder) ellipse than the top.

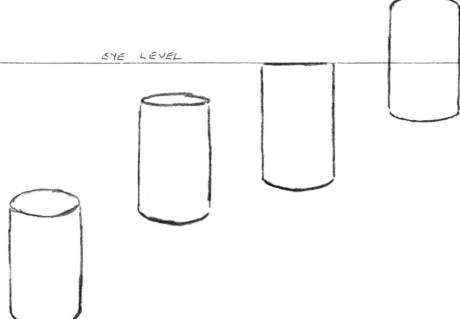

EYE LEVEL

The closer the top of an object like a can gets to your eye level, the narrower the ellipse, as shown here. When the top of the can is precisely *at* your eye level, there is no more curve visible—what you see is a straight line. And if you raise the can above your eye level, the top ellipse is now the fatter one. An ellipse near eye level is narrower than one farther from eye level because you're seeing it in more severe perspective.

Circular Objects

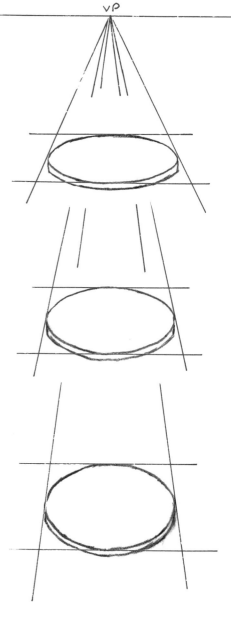

Now forget about beans. Let's talk MONEY! **Above** is a picture of my first royalty payment for writing this book. Let's remove what the IRS will claim. That leaves us with about seventy-five cents, **above right**.

Notice that each coin is an ellipse drawn in a square in perspective. The farther away from your eye level, the fatter the ellipse.

Let's look next at a landscape example. In the sketch **above**, the barn and one of the silos seem to have withstood weather and age. The other silo was done by a guy from Pisa.

The problem with the leaning silo is one of exaggerated perspective. The bands encircling the silo have been given too much curvature. This is usually caused by starting the drawing of the bands at the wrong place. If you start near the bottom, where the eye level is in this case, you'll naturally enough give each succeeding band more curvature as you go up the silo—the ellipses get fatter as they get farther from eye level. By the time you get to the top band, you give it more curvature than all the rest; you've overdone it and your silo falls over backwards.

A way to avoid this is to start at the end with the *maximum* curvature—the top in this example—and then work your way toward the other end.

Exercise: **Curves and Eye Level**

EL

SILO 1

SILO 2

EL

EL

SILO 3

EL

Here is a simple exercise to help you practice getting curves right. You'll notice the exercise does not ask you to draw perspective squares and inscribe curves within them. You could proceed in that manner, but that would take a lot of work—ugh! And even so, you'd still need to resort to trial and error just to get the perspective squares feeling right.

These parallel vertical lines are the sides of three silos. The silos have flat tops and bottoms. I've indicated the eye level in each case. Complete each silo by drawing in perspective its top, bottom, and five or so intermediate bands, keeping in mind how the eye level will affect the curvature of the bands.

Combinations of Cylinders

Many of the objects you draw are not neat, single cylinders, like the silo or a can of beans or a stack of coins. Some are odd combinations of intersecting shapes. One of the most common objects we draw is a tree, and its skeleton may be thought of as a network of intersecting cylindrical shapes. Imagine this tree, **top**, to be composed of cylinders or a bunch of pipes installed by a crazed plumber, **bottom**.

Sometimes it's easier to visualize pieces of pipe stuck together than to see what's happening to tree branches. I paint trees often, yet I still find this concept extremely helpful when I'm having trouble getting branches to advance or recede. You could play with the same idea by holding cans or other cylindrical objects at various angles to each other, although you'd be limited by how many objects you could manage. If there's a Tinkertoy set in the house, you can build a quite respectable three-dimensional tree from its parts.

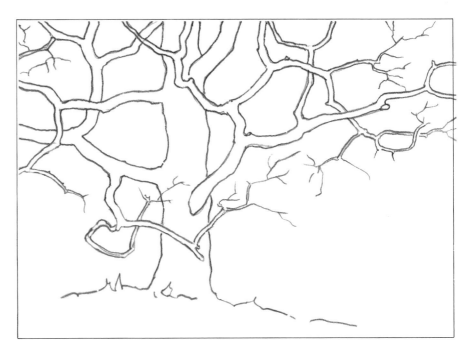

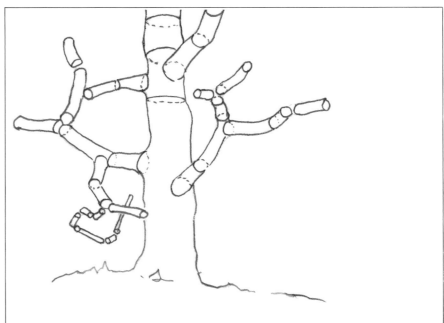

Combinations of Cylinders

People

You can apply the same idea to the human body to give it form and put its parts in perspective, **right**.

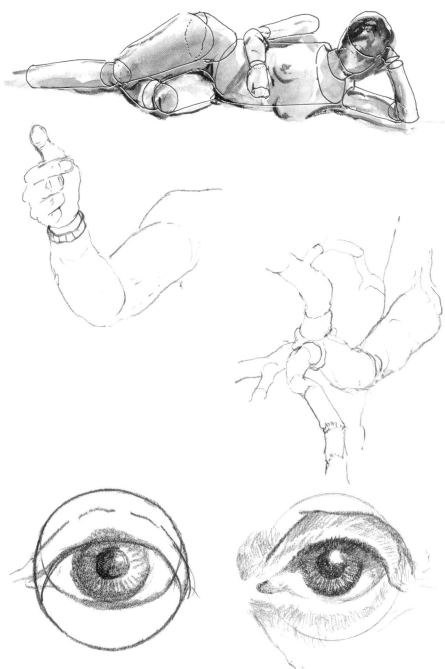

People are full of curves! You might not at first think of human anatomy as an appropriate topic in a book on perspective, but please reconsider. One of the qualities we usually strive for in a drawing of a person is a sense of form, or solidity, as opposed to flat critters with no depth. And physical (as opposed to intellectual) depth is what perspective is all about. In a landscape we're concerned with miles of depth; in people we're concerned with inches or feet.

The human trunk and limbs are not so different structurally from the tree. In both cases, it's helpful to think of the parts as cylinders or approximate cylinders connected in a variety of ways. As with drawing trees, such analogies are helpful in trying to show human limbs advancing or receding.

(The term *foreshortening* is usually used in discussing drawings such as these. That simply means getting the appearance of depth by shortening certain lines, such as the lines of the arm or the lines of the branch. When we turn a building away from us so that one of its sides appears to be shorter than we know it to be, we're foreshortening that building.)

Thinking of the body as a combination of cylinders will help you to get it right. When you do a torso or an arm or a leg or a head, "draw through," as discussed in Part Two, to get a feel for its roundness. When you get down to smaller details, such as noses and eyes, "draw through" them and see them as solid objects, not simply outlines. It's common, for example, to see eyes expressed as flat almond-like shapes.

If you start with the understanding that an eyeball is nearly spherical and that lids wrap around this sphere, you'll come closer to drawing a believable eye.

Add some shadow cast by the upper lid and some shadowing (modeling) as the eyeball curves away from us, and your eye begins to live.

Combinations of Cylinders

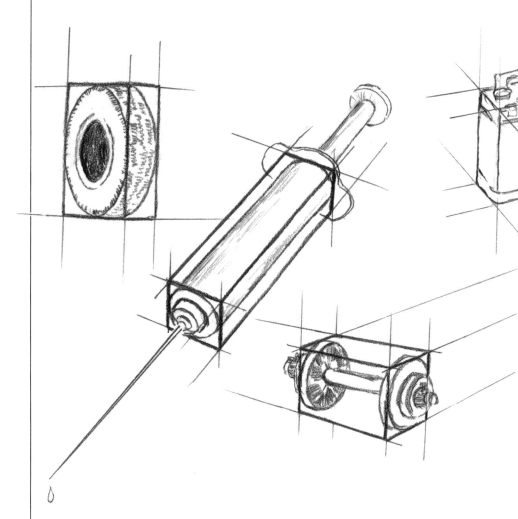

Box Them In

As the examples of the tree and the human body illustrate, not all curved objects are upright cylinders. But whatever the subject, curved or not, it can be an enormous help to sketch in some construction lines and put objects in boxes, as shown here. This is helpful because an ordinary box is something we all are familiar with. It's an orderly, understandable thing. Anything we can force into a box, therefore, will also become more orderly and understandable.

Exercise: **A Tree as a Combination of Cylinders**

An effective way to make a tree limb come forward or go back is to show the curve where the limb joins the trunk or another limb.

In these two sketches, use a soft pencil to darken the appropriate portion of each circle or ellipse to make limbs go:

- Forward (F)
- Backwards (B)
- Sideways (S)

as in the example at **right**. Beginning with identical silhouettes, you'll see that you can end up with quite different trees.

When you're satisfied that the limbs go where they should, you might enjoy

giving the tree more life by doing some modeling. Choose a light source (the sun) and then carefully darken each rounded surface facing away from the light. Gradually fade the shadows as each limb comes around toward the light. You might also add some smaller, twiggy branches, which I've left out in order not to confuse the picture.

In the two sketches on the next page, use a soft pencil to darken the appropriate portion of each circle or ellipse to make limbs go as indicated.

Arches

There are many curved objects around us whose drawing is more demanding than that of silos, cans, trees, and vases. One of the most familiar is the arch. Arches come in all sizes and shapes, some elliptical, some circular, some parabolic, and others rather free-form.

Arches such as those built into many bridges and public buildings provide attractive shapes for drawings and paintings. Some are complex and defy any easy approach to their drawing, but most can be constructed using some of the basic ideas we've already explored. Suppose we have a simple bridge, such as the one **top right**.

We'll assume the top of the bridge is a level roadway without any curvature, although most bridges rise some toward their midpoints. Once you get a basic structure drawn you can easily add such details.

Where do you start? I would locate the eye level and then try the bridge freehand, as I would most subjects. But when I got in trouble (as I often do) I'd fall back on a little construction. First, I'd rough in a couple of light lines representing the upper edge of the bridge and the water line, and indicate the two ends of the bridge with a couple of vertical lines. The ends of the bridge might not be neat vertical lines, but you need some idea where the bridge begins and ends.

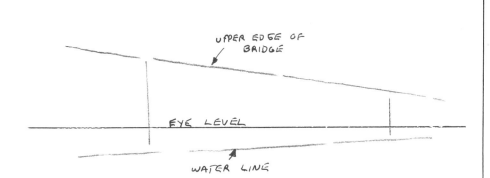

UPPER EDGE OF BRIDGE

EYE LEVEL

WATER LINE

Next, find the perspective center of the side of the bridge by crossing diagonals.

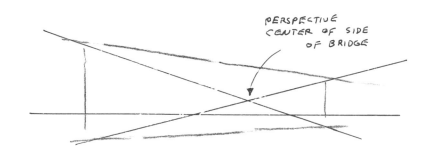

PERSPECTIVE CENTER OF SIDE OF BRIDGE

Arches

Now draw in a perspective line, *h*, representing the height of the arches. Each arch will curve up and touch this line.

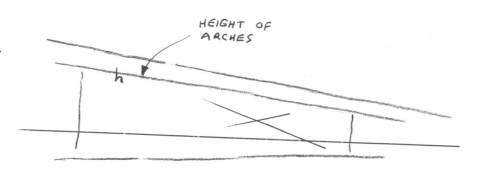

Freehand, draw vertical lines representing the widths of the arches. This is the same as placing windows along the side of a building. If there is an odd number of arches, one arch will be in the middle of the bridge span, so start by locating an arch with its perspective center at about the same point as the perspective center of the entire side of the bridge. If there is an even number of arches, draw two vertical lines, one on either side of perspective center, representing the width of the solid bridge support between arches.

Now work to either side of the start you made in the middle, guessing at increasingly larger arches and supports to the left and smaller to the right.

Arches

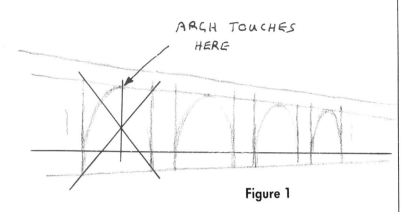

If you're satisfied with the space divisions, limber up your wrist and sketch in the arches. It might be helpful to locate the perspective center of each arch space first by drawing in the diagonals as I've done in **Figure 1** for the nearest arch. This will tell you at what point the arch is to touch the line you drew earlier showing the height of the arches. In small sketches, such as I'm using here, finding the perspective center for each arch is probably overkill. I show it only because in a larger, full-size painting, where all your dimensions might be much larger than here, such constructions can make a real difference.

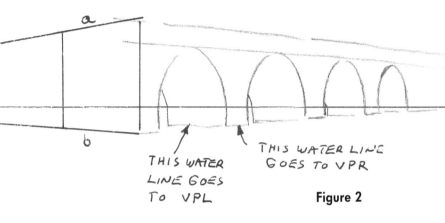

Figure 1

Figure 2

Now the bridge needs width, or thickness. If you can see through the arches from where you're viewing the bridge, then draw the spaces you see. In **Figure 2**, in addition to showing those spaces I've added a few construction lines here to remind you that this entire bridge can be thought of as a three-dimensional, rectangular solid with curved holes in it. Note that lines *a* and *b* slant toward a vanishing point at the left. Also notice that the water line under the arches aims for that same left vanishing point, while the water line on the face of the bridge heads toward the right vanishing point.

If this bridge were built of regular blocks of some kind, the mortar lines between the blocks would obey the rules of linear perspective. Those visible under the arches would slant toward the left vanishing point, as I've indicated, and those in the face of the bridge would slant toward the right vanishing point, shown in **Figure 3**.

All that's left is to embellish your bridge with detail and, of course, it would be nice if the bridge went from something to something.

This is a relatively simple bridge. There are many possible variations. When presented with any of the strange curves you may find in bridges, buildings, and other engineered objects, start with something basic that you're familiar with (such as the essentially rectangular side of the bridge in our example) and proceed from there. You can almost always mentally carve out sections that can be seen as rectangular solids, like that shown in **Figure 4**.

Figure 3

Figure 4

Exaggeration as an Aid to Seeing

Sometimes it's difficult to decide on the size or shape of something compared to something else because the objects are quite close in size and shape. You may decide that the difference between the two objects is too small to matter. But if it does matter and you still can't quite decide what's going on, you might try what I often do. I visualize the objects in some extreme or exaggerated setting and then see how they compare. For example, suppose I'm facing a stack of fat tires and trying to decide (a) whether the topmost tire appears rounder than a lower one, and (b) how much of the edge (the tread area) of the topmost one I'd see compared to the lower one, **below left**.

I know the topmost tire would look rounder (more nearly circular) and I know I'd see less tread of the topmost

one than the lower one. I had to pass that test before North Light would let me write this book. But if I were unsure, I'd mentally exaggerate the height of the stack until it was much higher, far above my eye level, until the top tire was so far over my head that I'd get a crick in my neck trying to see it, **below center**. It would be clear to me then that what I'd see way up there would be almost circular, certainly rounder than a tire down closer to my eye level. Not only would it clearly look rounder (that is, a fatter ellipse), but I'd see very little of its tread. If it were high enough, all I would see is its circular bottom and none of its tread. In other words, the higher a tire gets above my head (assuming it keeps level as it rises), the more I see of its underside and the less I see of its edges.

You can use the same trick in situa-

tions not really involving eye level. Earlier, when I was sketching the bridge and its arches, I was unsure how much space on the other side of the bridge I would see through each of the arches—that is, would those little openings get progressively wider as they came toward me, or smaller, or would they stay the same? (I was not actually looking at a real bridge at the time.) So I imagined the bridge extending into the distance in both directions. It was immediately obvious that at some point as the bridge "passed" me on my left I would actually be looking through a totally open arch and that I'd see the whole world on the other side of the bridge through that arch. It was clear, then, that I'd see more through the near arches than the far.

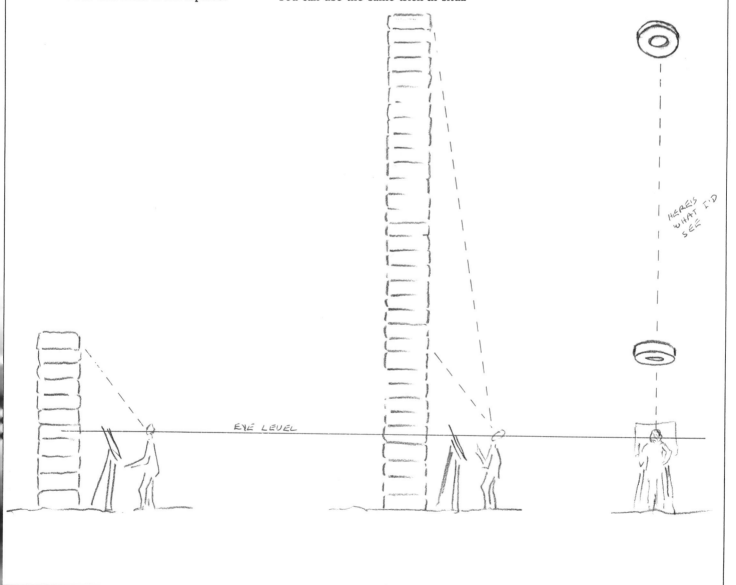

EYE LEVEL

HERE'S WHAT I'D SEE

99

Measuring Relative Sizes

It's important to keep measuring relative sizes of things as your drawing proceeds. In this view of the Capitol in Washington, D.C., that I dug out of one of my old sketchbooks, I had made a couple of notes to myself regarding dimensions.

The dome should be "more squat"; the width X should be about half again as wide as height Y. I simply used the pencil-and-thumb method described in Part One to compare various distances.

I find that I have somewhat more need to check up on myself when I'm drawing rounded objects than when drawing rectangular things. The curves throw me off. By the way, the little inset at the upper left reminded me that I was viewing the Capitol through a break in some tree foliage. When I later painted the scene, I moved the building farther off-center to avoid too much symmetry.

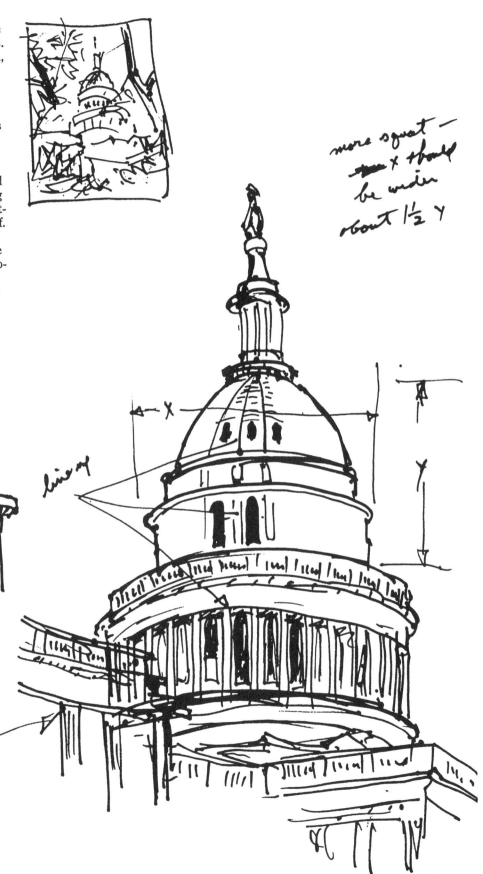

Measuring Relative Sizes

Here's another case where I found I needed to make constant measurements. I marked the floor to know where to return whenever my drawing or painting of this still life was interrupted. I was so close to the subject that every little shifting of my body caused me to see quite a different scene. (In a famous drawing by Dürer, an artist is seen drawing a nearby subject by closing one eye and keeping a pointed sighting stick directly in front of his open eye. The sighting stick is in a fixed position and cannot be moved by the artist. As long as the artist keeps his open eye precisely behind the point of the sighting stick, he knows he has not moved the position of his head.)

In addition to being careful about my position, I made sure the light source was not disturbed so that today's shadows would still be there tomorrow. And I constantly compared the heights and widths of objects against one another, all by the pencil-and-thumb technique. There are lots of surprises when you measure objects close to you in a still life. You think you know how big one thing is compared to another, but because you're so close, size differences become magnified.

This picture taught me that there's another way you can be fooled when you are drawing objects such as a decanter or wine bottle. The differences in the curvatures of the two ends of the object can throw you off.

Let's say you're looking slightly downward at two items, a drinking glass and a wine bottle, as shown at **right**. In the glass, the curve of the bottom will appear more rounded than the curve of the top, because the bottom of the glass is farther away and its ellipse will be fatter than the top of the glass. That's fine as long as the top and bottom of the glass are essentially the same size. In the wine bottle, however, the top is much smaller than the bottom, and even though the bottom is farther away from you, its curve will appear less severe, less "rounded" than the curve of the top. If this doesn't make sense to you, try imagining a bottle whose top is a one-inch circle and whose bottom is a three-foot circle. No matter how you view this bottle, the top will have the "rounder" curve. Observing such details can make the difference between a convincing picture and one that is unexplainably awkward. The following exercises offer ways of making such curves more accurate.

Reflections, Phil Metzger, watercolor, 34″ × 44″

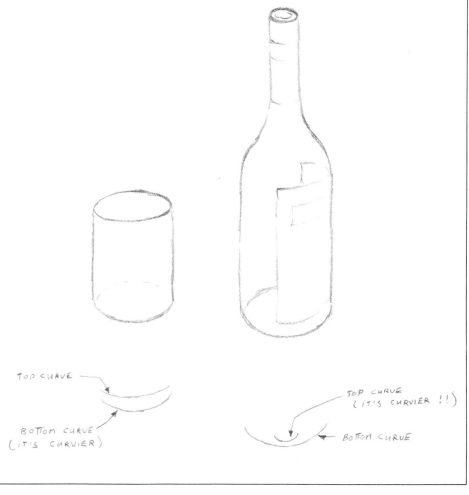

TOP CURVE

BOTTOM CURVE
(IT'S CURVIER)

TOP CURVE
(IT'S CURVIER !!)

BOTTOM CURVE

Exercise: **Checking Curves**

Find a curved object, such as a wine bottle, and set it up a few feet away on a tabletop. Imagine this bottle as part of a still life you intend to draw. The differing curves of its top and bottom can be a source of trouble. Here are two ways of checking up on whether you've drawn top and bottom curves correctly, relative to each other.

Method 1: Set up a piece of clear plastic and view the bottle through the plastic. With a grease pencil, draw the curve of

the top of the bottle. Then, standing in the same position, move the plastic down so that you see the curve you've just drawn adjacent to the curve you now see at the bottom of the bottle. By thus comparing the curves, you'll know how to draw them on your paper.

Method 2: Sketch the bottle on your paper. Then cut a piece of scrap paper carefully to fit the curve of either the top or bottom of the bottle in your drawing. Hold the curved cutout at arm's length

between you and the wine bottle and see whether the cutout curve matches what you see on the bottle. Change your drawing until you get a drawn curve to match the real thing. Then hold up the cutout and compare it to the curve at the other end of the bottle. Again, adjust your drawing to get the two curves right relative to each other.

Exercise: **Achieving Symmetry**

Drawing symmetrical objects and having them come out looking symmetrical gives a lot of us a headache. Here are two ways you can help get shapes right.

Be careful using such techniques. If you get too rigid and fussy, your drawing will be correct and boring.

Method 1: If you really want good symmetry, try this. Draw the bottle the best you can—just its outline. Then trace its outline on a scrap of tracing paper. Measure the distance between the two sides of the bottle and draw a line cutting the bottle in half from top to bottom. Fold the tracing paper along that line so that you'll see one half of the bottle laid over the other. Bet you a nickel they won't match.

Exercise: **Achieving Symmetry**

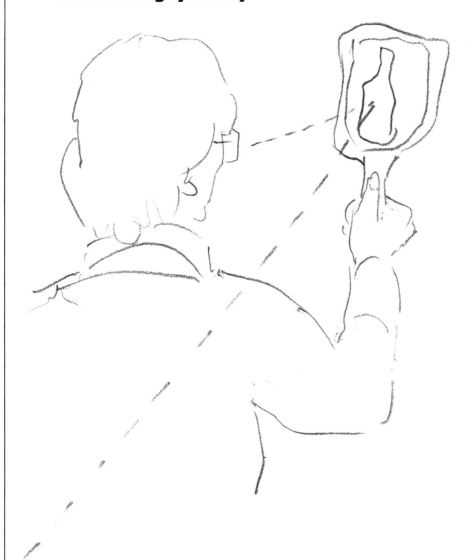

Method 2: Get out the old wine bottle again (you've probably emptied it by now). Draw its silhouette. The rounded tops and bottoms of such objects give us trouble enough, but so do the rounded shoulders where the bottle's neck broadens into its body. Unless you're either lucky or gifted, your first shot at the bottle will probably not be symmetrical.

Turn your back on your drawing and look at it over your shoulder in a mirror held in front of you. You'll see your drawing in reverse and instantly spot deformities you never saw looking at it straight on. We have a psychological tendency to draw things with a certain directional bias, and seeing the drawing in reverse shows up that bias. You'll be absolutely dumbfounded, if you haven't tried this before, at the flaws that will show up in the mirror.

Actually, this works whether or not the thing you're drawing is a symmetrical object. Use the mirror no matter what you're drawing. It's particularly handy when doing a portrait. Many people have the tendency to get a face, for example, out of whack—one eye higher than the other, maybe. That sort of goof will instantly show up in the mirror.

More Vanishing Points

In Parts One and Two of this book, we discussed pictures in which there were but one or two vanishing points. The truth is, friends, there are more vanishing points than you can shake a stick at. Luckily, we usually deal with only one or two, sometimes three. But it's important to understand that there may be more. Otherwise, one might be tempted to force every line in a picture to go to one or two vanishing points, with disastrous results.

We'll start with three. I've already shown you lots of dinky little buildings like the one at **top right**, with two vanishing points, one somewhere to the left and one to the right. We've so far let lines such as *a* and *b* seem parallel. Actually, though, they're not. Consider this: those lines are actually receding from you, are they not? Aren't they headed into far left outer space? Tilt a pad of paper the way the roof is tilted. Do you see that the edges corresponding to *a* and *b* in the roof are headed away from you?

They are parallel lines, and our laws of the perspective jungle tell us that parallel lines receding from the viewer seem to meet, or "vanish," at a vanishing point. The difference between these lines and the other parallel lines we've dealt with is that these lines vanish at points not on the eye level. Only HORIZONTAL lines vanish at eye level. All these other queer lines vanish elsewhere. Let's find out where.

If you lay a straightedge along lines *a* and *b* and extend them to find where they meet, you'll get a drawing like the one **bottom right**. Where they meet (we'll call it VP3) is directly above one of the good old garden-variety eye-level vanishing points (in this case, VPL).

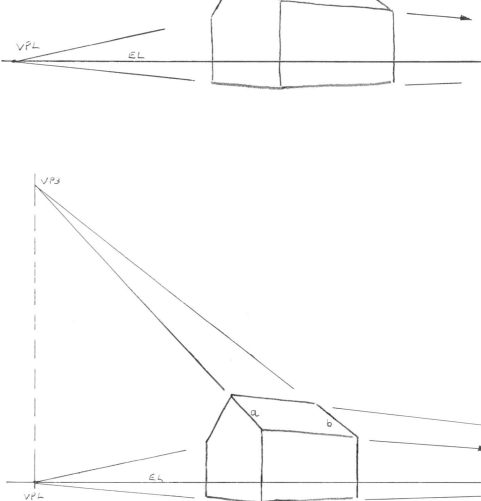

More Vanishing Points

Very often we draw roof edges (such as *a* and *b*) so that they diverge rather than converge **top right**—and, of course, that's just not correct. It's not only not correct, but more important, it doesn't look right in the drawing.

The reason these lines so often get drawn as though diverging is that, thanks to an optical illusion, that's often what appears to be happening. If you hold up your pencil and compare the tilts of these two lines on a real building, you'll see that they *do* converge, as theory says they should; but when you simply look at the building with your naked eyes, they might indeed seem to diverge. The illusion is caused by the other lines and shapes nearby. What's important is that the drawing will feel better if you make these lines behave and come together out in space. No need to do any measuring or locating of vanishing points; simply use your straightedge and aim the lines slightly toward each other.

You've probably already guessed at where a fourth vanishing point might be. Yes, the edges of the other side of the roof (*c* and *d*) are receding and they vanish at a point directly below one of the eye level vanishing points, as shown **bottom right**. All these vanishing points would not line up in so orderly a fashion if our building were not such a perfectly symmetrical, humdrum little Monopoly house.

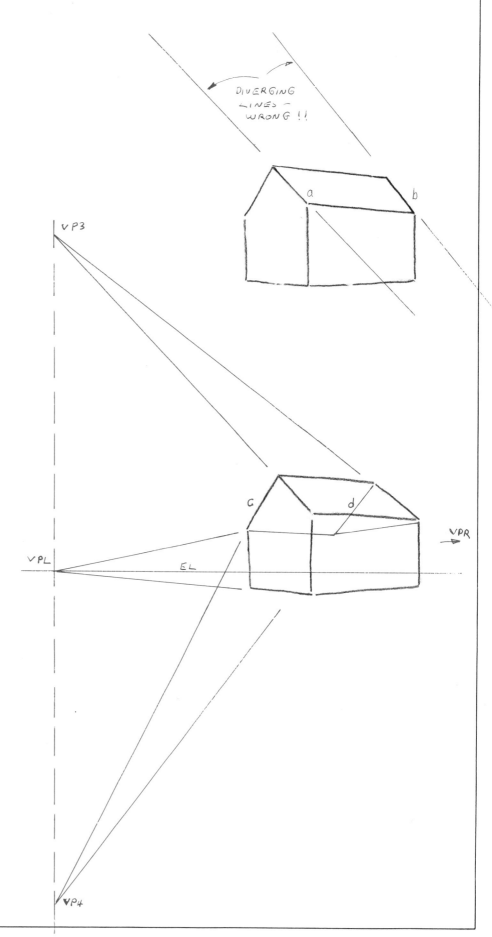

Some Vertical Lines Converge

There's a more important use of a third vanishing point than in these roof lines. So far, we've not molested the vertical lines in our buildings. We've left them vertical. That's appropriate if we're dealing with relatively low, squat objects, because all points along the vertical lines in such objects are nearly the same distance from our eyes. Those lines, in other words, are not visibly receding from the viewer.

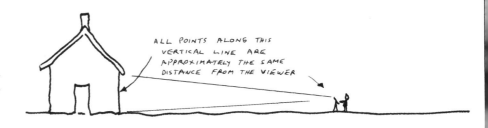

ALL POINTS ALONG THIS VERTICAL LINE ARE APPROXIMATELY THE SAME DISTANCE FROM THE VIEWER

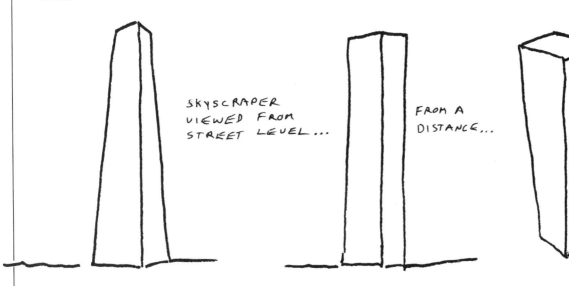

SKYSCRAPER VIEWED FROM STREET LEVEL...

FROM A DISTANCE...

AND FROM THE AIR

Imagine you're drawing a skyscraper from a point on the sidewalk near the foot of the building. Assume it's a rectangular blob, not a tapered building. As you glance up at the building, instead of looking like a rectangular solid, it looks something like the drawing **above**.

What you're seeing is the side edges of the building converging toward a vanishing point high in the sky. As you look up at the building, its parallel sides are moving away from you, and they seem to converge exactly as a pair of horizontal lines would appear to converge—only to a different vanishing point.

From a distance, say from another skyscraper's window, the scene might look like this.

If you were in an airplane that same skyscraper would look more like this.

The vanishing point for the vertical edges of this building is somewhere around China. Notice that our old friends, vanishing points left and right, are still with us, far out of the picture. You, in the airplane, have a very high eye level, or horizon. The entire city is below your eye level.

Some Vertical Lines Converge

The use of a third vanishing point may be important if you are drawing any high object, or a group of high objects, as in a cityscape. You might be depicting a scene like either of those shown here.

In both cases I've kept the third vanishing point fairly close to the subject and have gotten a distorted, bunching effect. If that's not what you're after, you need to raise the vanishing point much higher (or lower, if you're doing a view from an airplane). As in two-point perspective, the closer in you bring the vanishing points, the more distortion you'll get. If you want all verticals to stay vertical in your drawing, as things might appear from a distant view, go ahead and leave them that way—in that case there will be no third vanishing point.

Let's assume you're drawing a cityscape from street level. There are a couple of things to watch out for. First, many "rectangular" skyscrapers are not rectangular at all. Some of them are built with gradually tapering widths so that at the top floors the width of the buildings is smaller than at street level. That means that some of the apparent tapering you see as you look up from street level is real. In other words, those tall "vertical" edges aren't really vertical. This tapering could throw you off if you're unaware of it because the third vanishing point for a tapered building will be lower than the third vanishing point for an untapered building standing right next door. If all the buildings in your scene were truly vertical (no tapered sides), they would all share the same third vanishing point.

Second, each skyscraper has its own set of left and right vanishing points, just as any other building would have. They both lie on the eye level.

I said earlier that there are billions and billions of vanishing points. The number actually is infinite. Although you'll rarely be concerned with more than three, it's enlightening to know that for every pair of parallel lines in a scene there can be a different vanishing point.

The important things to know about vanishing points, especially those not on the eye level, are (1) that they exist, and (2) roughly where they are. Knowing just that much will remind you to draw lines heading toward those vanishing points with an appropriate amount of convergence.

Knowing, for example, that the slanting roof edges of our Monopoly-game house really do converge toward a van-

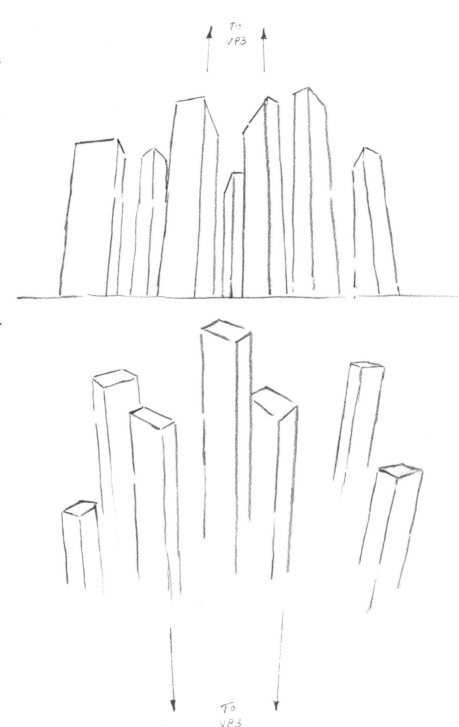

ishing point will stick in your mind and prevent you from making the common error of drawing diverging, rather than converging, lines. You need never actually find the exact location of that vanishing point. It's usually enough to know that it's "right about here at the upper left."

Exercise: **More Vanishing Points**

Locate at least ten vanishing points in this scene. An answer diagram is supplied on the next page.

Exercise: **More Vanishing Points**

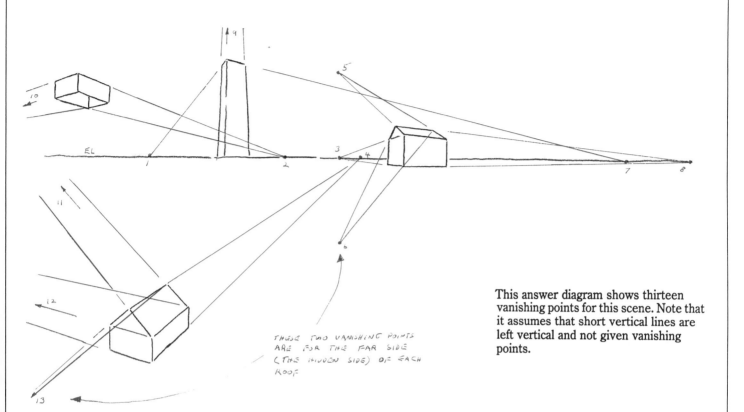

THESE TWO VANISHING POINTS
ARE FOR THE FAR SIDE
(THE HIDDEN SIDE) OF EACH
ROOF

This answer diagram shows thirteen vanishing points for this scene. Note that it assumes that short vertical lines are left vertical and not given vanishing points.

Exercise: **Roof Edges**

Correct sloping lines *a, b, c,* and *d* on these structures freehand. When you're finished, use a straightedge to make sure that the new lines you've drawn slightly converge toward their partners, *a', b', c',* and *d'.*

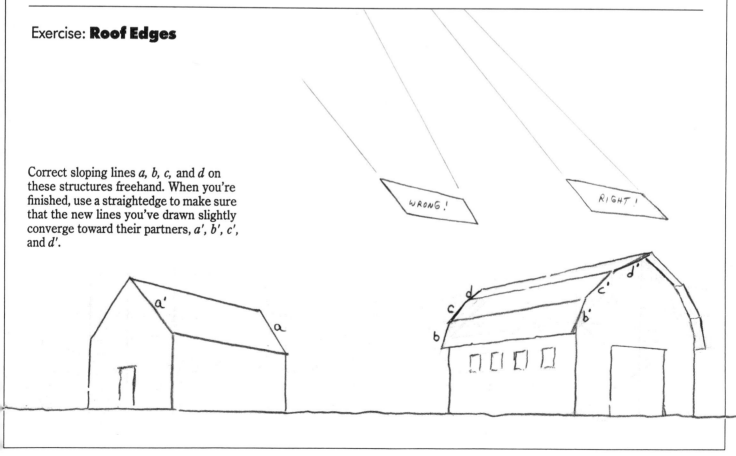

WRONG!

RIGHT!

Exercise: **Looking Up**

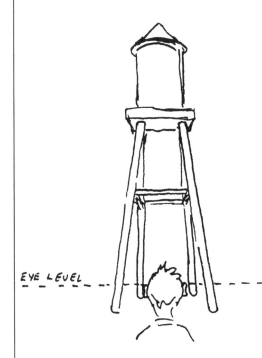

EYE LEVEL

Here is a simplified water tower seen from a distance by a viewer standing on the ground. Loosely sketch the tower from the same eye level, but closer to the tower, so that you would have to tilt your head far back to see the top.

Hints:

1. You might start with the platform on which the tank rests, since it's the only thing in this scene that's a good old rectangular solid. Draw the platform on which the tank will rest, drawing in one-point perspective.
2. You can place the tank on the platform properly by locating the perspective center of the hidden top of the platform. The tank is cylindrical, its sides vertical. Above your head it would look something like this if you could see it without anything else in the way.
3. Do plenty of "drawing through." Show the conical top through the tank, the tank through the platform, etc.
4. How about the cone on the top? Whether it will be visible in your view depends on (a) how close you are standing to the structure, and (b) how high the cone and the tank actually are. Some possibilities are shown.
5. Assume the legs and braces are all round pipes with no actual taper. (They'll taper some, of course, when shown in perspective.)

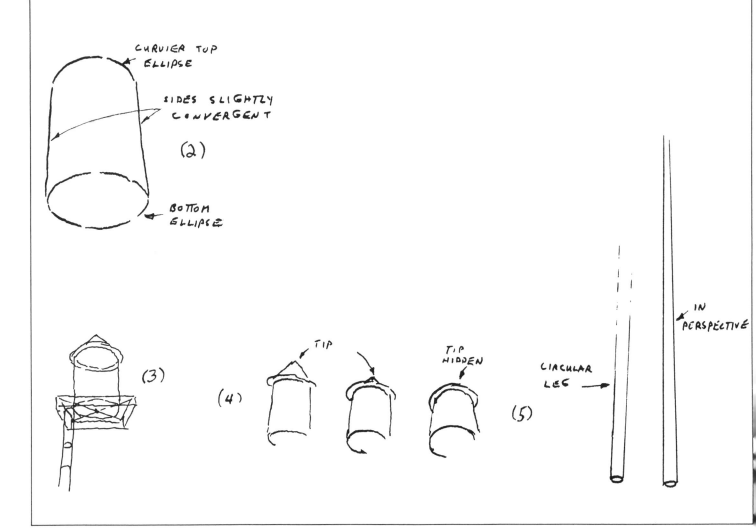

Inclines

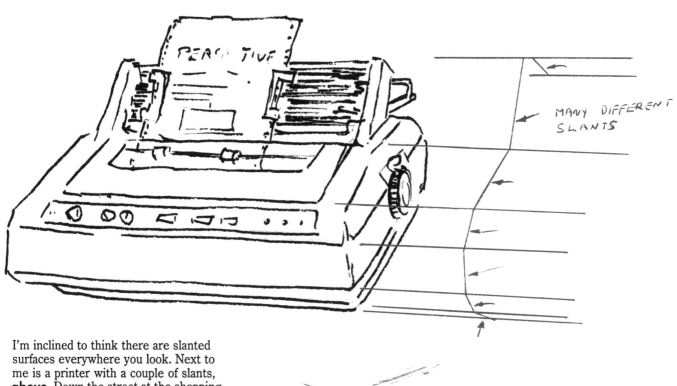

I'm inclined to think there are slanted surfaces everywhere you look. Next to me is a printer with a couple of slants, **above**. Down the street at the shopping center are sidewalk ramps, **right**.

And then there are the sloping roofs of houses and barns, lots of tilted roads and streets, fields that don't lie level, and a great variety of stairways. Including inclined surfaces in a drawing very often provides the spark that revives an otherwise comatose picture. Inclines sometimes bedevil the artist, but they're not so hard to do if (you guessed it) you start off with plain, old-fashioned linear perspective.

The simplest kind of incline is a wedge-shaped object that looks like this when viewed from the side.

That same incline looks like this when seen in perspective.

The wedge also can be seen as half a rectangular box.

Inclines

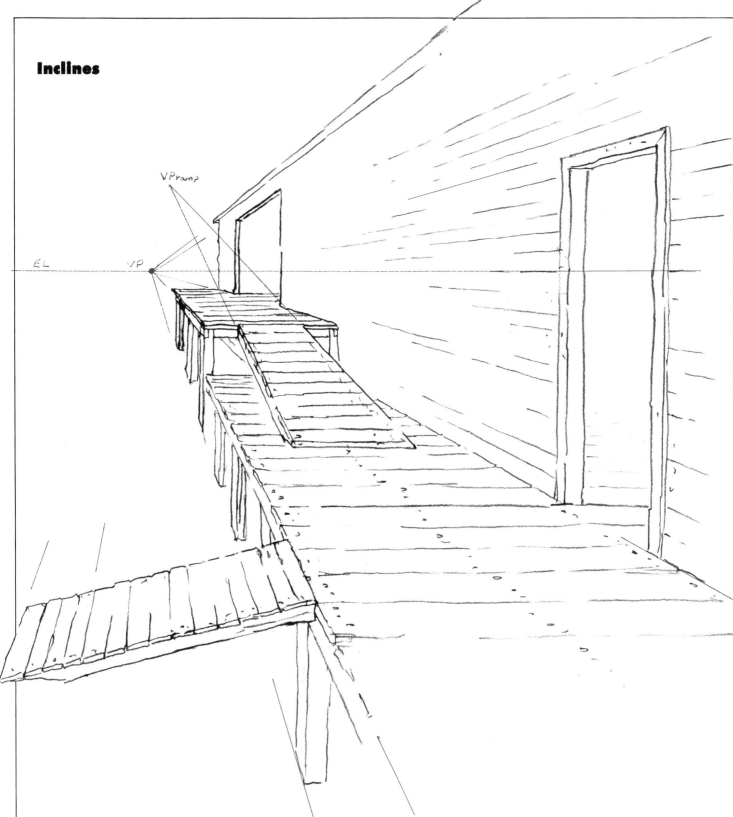

Drawing most inclines is as straightforward as drawing the sloping roof of a house—something we've already covered. If you forget about the sloping lines for the time being, and first draw (in perspective) the rectangular shape into which the incline will fit, then you can easily slice the rectangular shape in half, erase the part of the rectangular box you don't want, and what's left is a wedge shape. Don't forget that the sloping

edges of an incline will have a vanishing point, provided the incline is actually of uniform width.

Here is a combination of inclines at a loading dock. I've drawn the building and the platforms in one-point linear perspective (remember Part One?). The vanishing point to which all *horizontal* receding lines retreat is VP. It's on the eye level. The distant ramp, however, is not horizontal, not parallel to the ground, so

its vanishing point is not at eye level, but, in this case, above it at VP ramp. The boards in the nearer ramp recede to VP because they are ordinary horizontal lines, each parallel to the ground. The side edges of this ramp don't have a vanishing point because all points along either of these lines are, for practical purposes, equally distant from the viewer.

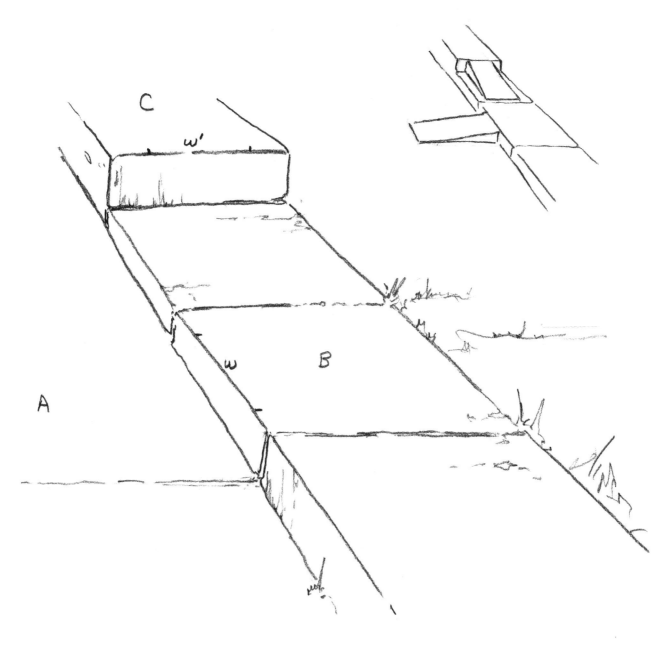

Construct a ramp going from level A to level B and a second ramp from level B to level C. Make their widths approximately as indicated by w and w', and their lengths whatever you wish.

Hint: This scene is drawn in one-point perspective, with the vanishing point at the upper left. Locate the VP. Then construct two rectangular boxes, one fitting up against w and the other against w'. When you slice a wedge from each of these boxes you'll be left with something similar to what is shown **above right**.

Roads, Paths, and Streets

Although a road or path leading up to a building may seem a minor part of a picture, properly done it can be very effective in suggesting depth in the scene and in describing the flatness or hilliness of the landscape. At **right** is a scene with no obvious means of getting to the house, built by the bozo who did my house, no doubt. Below that are three alternative paths one might use to lead up to the house.

Take a small piece of tracing paper and trace the lines of the three paths. Overlay the house sketch with the first path. It's clearly not effective. It suggests that the path has the same width all the way, which in turn suggests that the path is vertical to the viewer's eye—either that or this house sits on a cliff and the path is really a ladder to get up the cliff!

Try the second path. It has what the first path lacks: linear perspective. Using this path, one would conclude that the ground leading up to the house is more or less flat. This path introduces depth.

Try sketching a similar path, but one that does not appear to broaden quite as much as the second path—a path somewhere between the first and second examples. Notice that narrowing the path tends to make the distant house feel more as though it's on a rise and the path is climbing upward to get to the house. The extreme of this, of course, is the first path, where the hill leading up to the house indeed seems to be very steep. The more you broaden the path as it comes forward, the more the land seems to flatten, up to a point. When the broadening becomes too pronounced, the perspective will simply seem exaggerated. You need to play with various widths to find what feels right.

The paths we've considered so far are pretty rigid. That might serve well in some pictures, but often you'll want to introduce some zigzag in the path to effect more interest. Overlay the scene with the third example. What we find here are a couple of perspective techniques at work. Not only are we using linear perspective, as in the second example, but size variation, as well. The path can be thought of as a series of segments having similar shapes, but decreasing in size as they recede, **bottom**.

Roads, Paths, and Streets

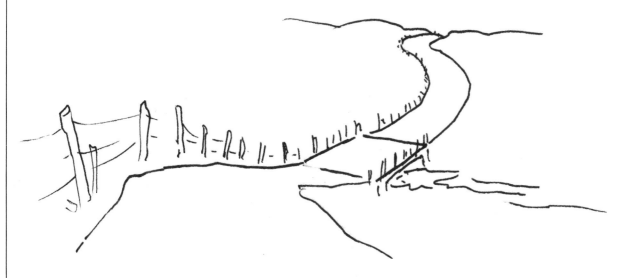

Another effect of the zigzaggy path is that it pulls the eye into the picture along a more scenic route. The straight path just zaps you right up to the house, no fooling around along the way.

Paths, roads, and streets are effective elements in conventional landscapes. They provide a thread around which buildings and other elements may be woven; they offer an easy means of suggesting depth; and they provide a terrific means of focusing attention. Drawing them is sometimes tricky, but if you'll think of them as thin slabs in perspective and be aware of the tilt each segment might have, the drawing will come more easily. Study what's happening in the scene **above**.

Think of this road as comprising several segments, 1, 2, 3, and so on through segment 7, **below**.

I've shown perspective lines (they're only rough approximations) and vanishing points for some of the segments. Segment 3 appears to be fairly horizontal as it spans a bubbling brook. It can be seen as a rectangle having its vanishing points as shown. Segment 1 is also roughly level; we know this because its vanishing point (it happens to appear in one-point perspective) lies on the eye level. The remaining segments are inclines having vanishing points above or below the eye level, as in the case of roofs we discussed earlier. Estimate for yourself where the vanishing points for segments 4 and 5

might lie. You'll find them quite high above the eye level.

If you have a problem making a road (or path or street) do what you want it to do, try visualizing it in rectangular segments, some of which may be inclines. Draw in the level, establish very roughly where the vanishing points might lie when the sides of the segments are extended, and vary the positions of these vanishing points to get the degree of tilt you want. But as always, SKETCH FIRST and resort to vanishing points and construction lines only to help solve problems.

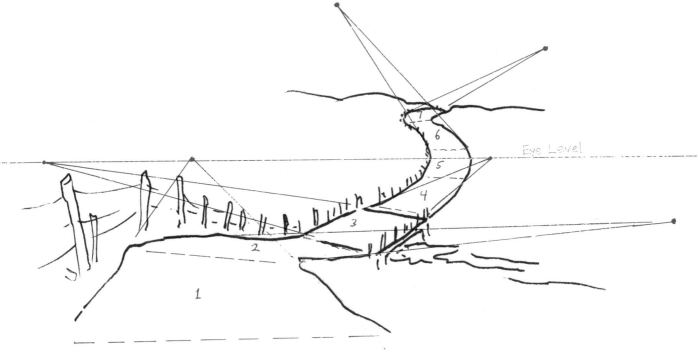

Roads, Paths, and Streets

Often the effective drawing of a road or street depends on clues other than the lines representing the edges. We just discussed the value of gradually diminishing sizes of segments as a zigzagging road recedes. Another effective perspective technique is to pay attention to details of things along the road. **Above**, for instance, the fence posts and utility poles do more to define the road than the lines of the road itself.

If you look closely you'll see the tops of the posts beyond the hill—they tell you that the road dips as it goes over the crest of the hill and that it turns some toward the right. Some subtle detail can be more interesting and enlightening than a ton of more obvious information.

One more example. In the sketch **center right** we know there is a downhill segment of this road that is invisible in this view. How do we know?

The discontinuity between the nearest road segment and the more distant segment tells us. The fact that width b is so much less than width a tells us that something sneaky is happening between a and b, and intuition fills in what that something must be. The fact that the distant segment is also out of line with the near one helps, too, but even if the segments were all neatly lined up as at **bottom right**, we'd still know we were looking at a roller coaster road.

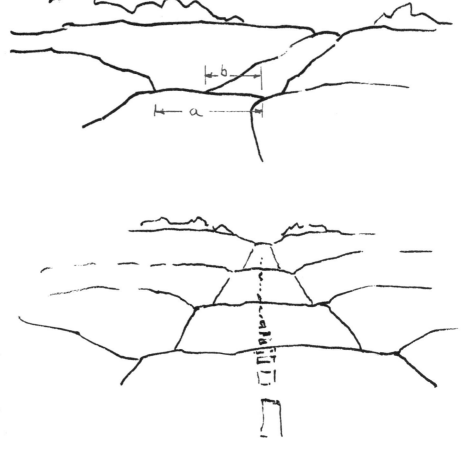

Exercise: **Which Path?**

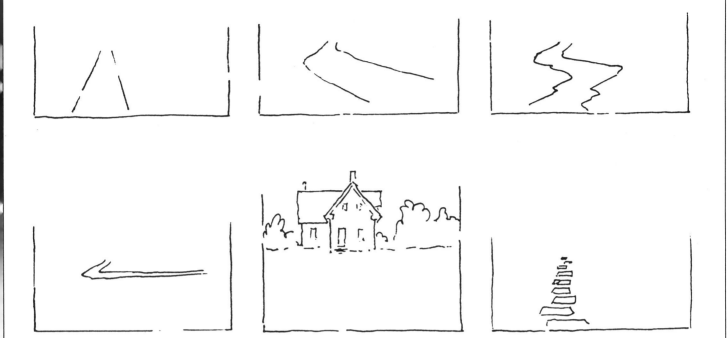

Here are several paths, any one of which might be used to lead up to the house. Using erasable soft pencil or charcoal, place each of these roads in the scene to get a feel for some of the options you have. There is no "correct" answer, only a variety from which to choose. See what each choice does for the feeling of depth in the picture.

Fields and Streams

If you were to paint flat country fields, you might have something like the first drawing at **right**.

On rolling terrain, plowed furrows or rows of corn will follow the curves of the ground and maybe you'll see a scene like the second drawing at **right**.

You can find all kinds of perspective in such scenes. You will see rows of corn or plow marks getting closer together in the distance, just as linear perspective says they ought to; near stalks are tall and distant ones are pip-squeaks; near stalks are full of luscious detail, distant ones fuzz and blend together; near ones are strong-colored greens and yellows and browns, distant ones are paler and cooler. It seems that such fields really are putting on a perspective show for us! If you can get out and sketch such seemingly simple scenes, you'll learn a lot about perspective.

There are some things you'll observe in these scenes that, if copied exactly as observed, may not work in the painting. Often, for example, there will be a nearby field of very strong blue-green (a field of rye, perhaps) and in the distance strong warm colors (newly plowed earth, ripe hayfields). The pattern of colors may look great out there, but on your canvas the warm distant colors may scream to come forward and the cool nearby colors may retreat into the background.

Such apparent anomalies occur all the time. Don't be bound by rules such as, "Warm colors advance, cools recede." Sounds like a military marching order. Only use the "rules" as guidelines to help smooth over problems. If the colors aren't working on your canvas, then take whatever liberties you must to make them work, but don't blindly interchange the green field with the yellow one! Simply play with the colors gently until they no longer complain. Maybe all you'll need in this example is to warm up the green a little and dull the yellow.

It may be that you can leave the colors alone, but play with the other perspective techniques you know and use them to help get the depth you want, ignoring the

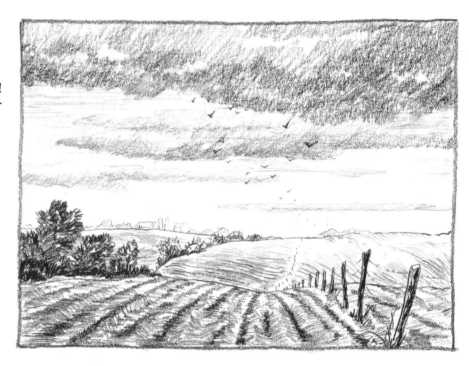

apparent inconsistency between the forward cool area and the distant warms. It may be that including fence posts whose sizes diminish rapidly as they go back into the picture, or trees or hedgerows that do the same, will help a lot. And detail up close, fuzziness in the distance, will certainly help. You may even have a strong layer of clouds overhead which you can paint as progressively smaller

blobs as they recede into the picture. Add to this some overlapping objects, and pretty soon you'll have a picture whose color reversals are inconsequential.

Fields and Streams

Sometimes you'll have a stream meandering through your fields. You can pretty much treat a stream as if it were a road on flat ground, with appropriate curves or zigzags, but with a width more likely to vary than that of most roads. If there are rocks or wavelets or other details you want to include, make the nearer details more evident than the distant ones, just as you would draw anything else. There is one caution I would mention: bodies of water, other than falls or rapids, are flat. You can enhance their flatness by a few well-placed *horizontal* strokes, as at **top left**, but you may have to invent some of these horizontal strokes. If you paint too many of the actual ripples you see, as at **bottom left**, and they are not horizontal, you may destroy the feeling of flatness. This is one time when painting faithfully what you see may not be a good idea.

Stairs

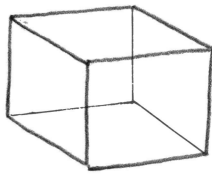

SIMPLE STAIRS
ENCASED IN A
WEDGE CUT
FROM A BLOCK

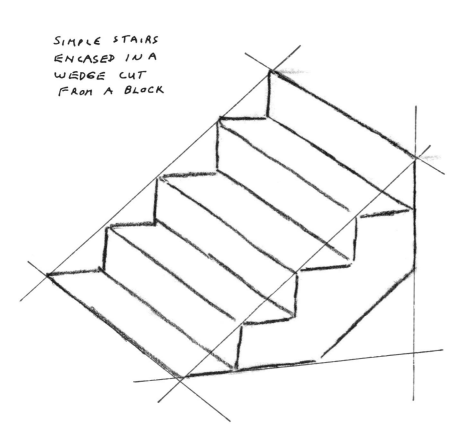

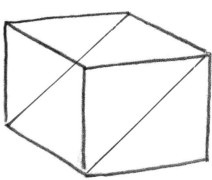

Stairways look complicated, but basically they are a variation of a simple incline which in turn is a rectangular block sliced diagonally in half, **right**, like the cheese wedge in an earlier sketch. **Above** is a basic set of stairs.

Stairs

This is a sketch that I intended to work up as a finished drawing, but never did. Everything sagged in the old Harper's Ferry building, and its linear perspective is far from perfect. My eye level was about in the middle of the right-hand steps. The upper landing sagged so much that instead of seeing slightly up under it, I could see the tops of its boards.

I'll take you step by step through the process I used to draw the stairs in this scene.

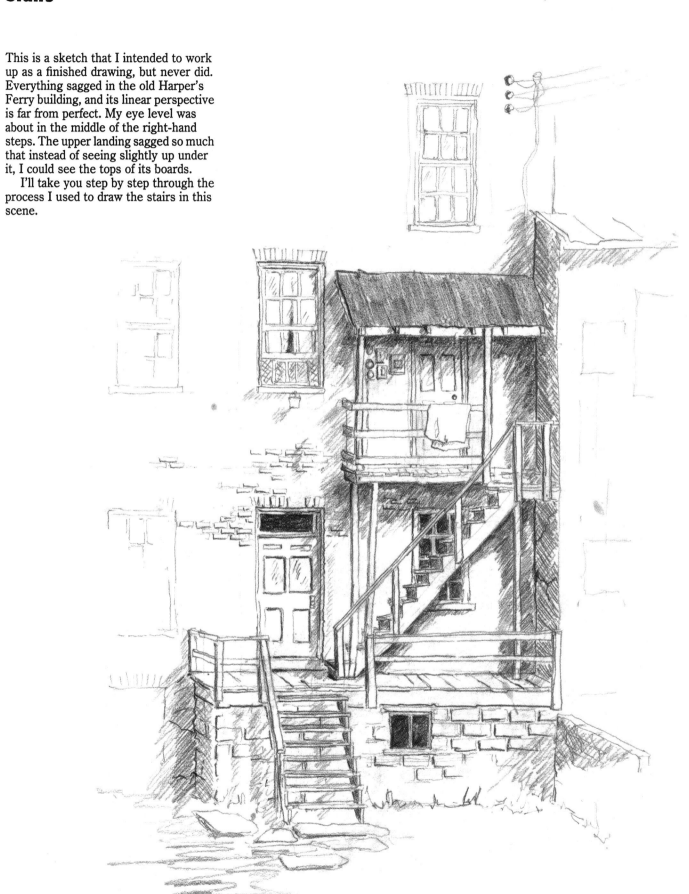

Stairs

To draw the higher set of steps, I didn't draw a wedge, or incline, in perspective, although I kept such an image in mind. What I drew first were a couple of light lines representing the direction and outer bounds of my steps, as in **Figure 1**.

Those lines kept my stairs aimed in the right direction and defined the area they would occupy on the drawing. Then I drew in essentially horizontal and vertical lines showing the shape of the near side of the stringer (the long sawtooth-shaped support for the steps). This located all the individual steps, **Figure 2**.

Next I drew the "horizontal" lines for the top edge of each step, **Figure 3**. Then I added the vertical far edges (the sawtooth shape on the other side of the steps), **Figure 4**.

After that it was a simple matter to add the step thicknesses and to tilt the steps gradually as they descended below my eye level.

Below is another set of steps I painted with conscious attention to perspective. I've overlaid the painting with a few perspective lines. Notice, first, that in a subject such as this, things sag and perspective is not perfect. It's enough that the right and left slants of appropriate lines are generally correct.

The set of steps in the picture is adjacent to the shed, and, if built "correctly" and not ravaged by age, would share the same vanishing points as the shed. Indeed, if you project lines far enough to the right, they do seem aimed toward the same vanishing point, but left-leaning lines do not. The lines I've shown headed left from the steps meet the eye level roughly where the old tree stands at the left of the picture. In a proper structure, however, those lines would meet the eye level much farther left, in fact at the same point as the line from the roof edge, line *a*. The fact is, the steps have sagged (haven't we all), and furthermore, they weren't made all that perfectly in the first place.

There are other perspective techniques at work here. The detail in the center of the picture helps focus the eye there; the suggested path, wider in the foreground than at the steps, leads the eye to the steps; there is some fuzziness in the distant background; the sudden change in value at the doorway makes the inside of the shed seem deeper, farther away, than the face of the shed; and many objects overlap one another and push each other back.

Figure 1 Figure 2

Figure 3 Figure 4

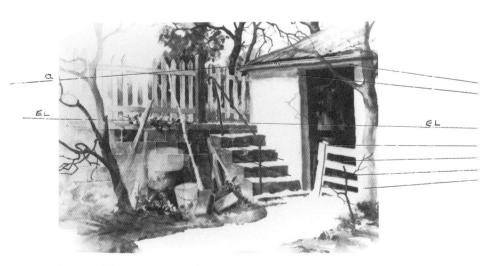

Farmyard Steps, Phil Metzger, watercolor, 28" × 36"

Exercise: **Drawing Stairs**

Here's an exercise showing one way (there are many different approaches) of drawing steps. If you'll do the exercise along with me by following the approach I've outlined, I think you'll find the construction not all that baffling. I wouldn't want to kid you, though—drawing a set of steps to fit a particular space (the kind of job an architect might face) can be tricky. But it can also be fun. If you understand the basics of linear perspective presented in this book, you can figure out most step problems. If you get into weird situations involving, say, circular stairways, things get much more complicated, but even there you can build your steps within perspective cylinders.

Use the worksheet on page 126 and follow along with me. The job is to draw a set of stairs between line *a* and the doorway on the raised floor. This is an approximate method. There are books full of exact architectural methods for building stairs, but that's not our interest here. You know the old saying . . . "good enough for government work!"

Start with the knowledge that the width of the stairs at the top is *b*. Since the top of the stairs will be a little farther away from you than the bottom, *b* should be a little shorter than the foot of the stairs. How much shorter? Drop vertical lines from each end of *b* to the floor. Where those verticals hit the floor, follow the floorboard lines out to *a*. Where the two floorboard lines chop off *a*, you have the width and location of the foot of the stairs. (You realize, of course, that the floorboard lines go to the left vanishing point.)

Lightly draw the two lines between *a* and *b* which define the incline, or wedge shape, of the stairs.

Decide how many steps there are to be. We'll assume it's eight, including the top step at *b*. Divide one of the verticals you drew earlier into eight equal parts.

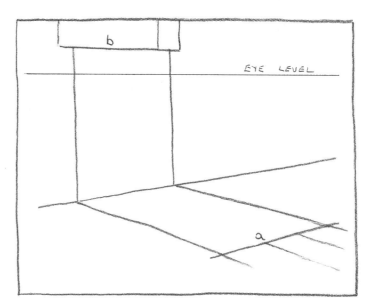

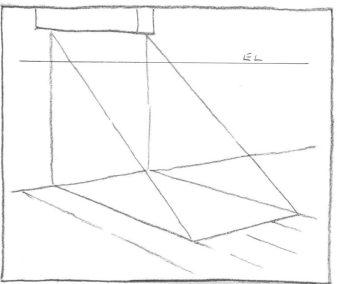

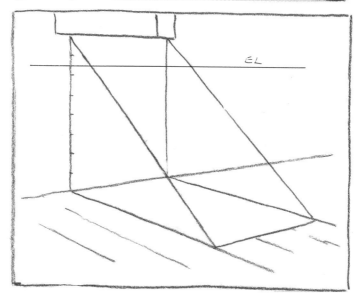

Exercise: **Drawing Stairs**

Draw light construction lines through these points toward VPL. Now we have the slopes of the steps.

Draw construction lines from VPR to the points where the slopes of the steps hit the incline of the steps. Now you have the front edge of each step.

Draw the short vertical lines defining the near end of the risers (the vertical pieces between steps). Darken the resulting sawtooth shape.

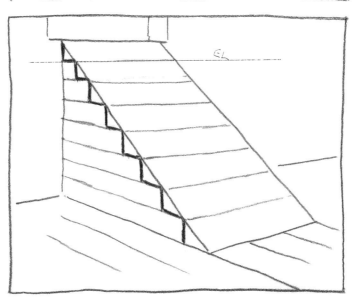

Draw lines to VPR from each of the low points on the sawtooth. Those lines define the rear edges of the steps. Drop short verticals to mark the right-hand edges of the risers.

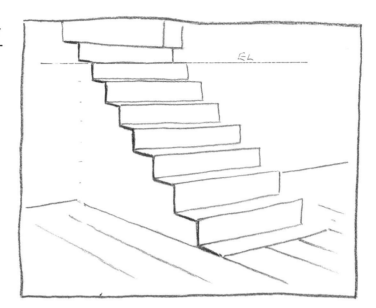

Complete the right-hand sawtooth with lines drawn to VPL.

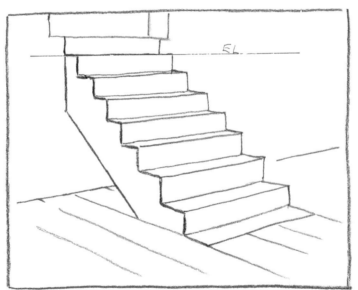

The basic stairs are complete, ready for details. These details can easily be done freehand, but as you see, they still follow the rules of perspective, the siren calls of those sexy vanishing points!

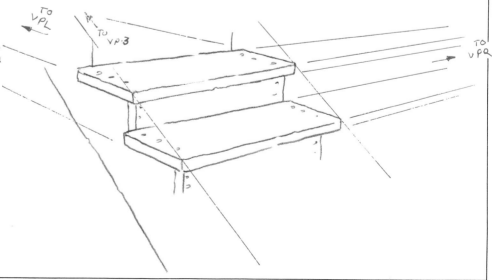

125

For directions, see page 123.

Beyond Eyeballing

Sometimes we get involved in subjects that demand more accuracy than is possible with casual eyeballing or thumb-and-pencil measurement. Here is a method of determining how evenly spaced objects of equal size diminish in size and spacing as they recede.

Upright Objects

Suppose you're drawing a neat row of utility poles stretching across a flat piece of land. The poles are all the same size and the spaces between them are all equal. How do you proceed?

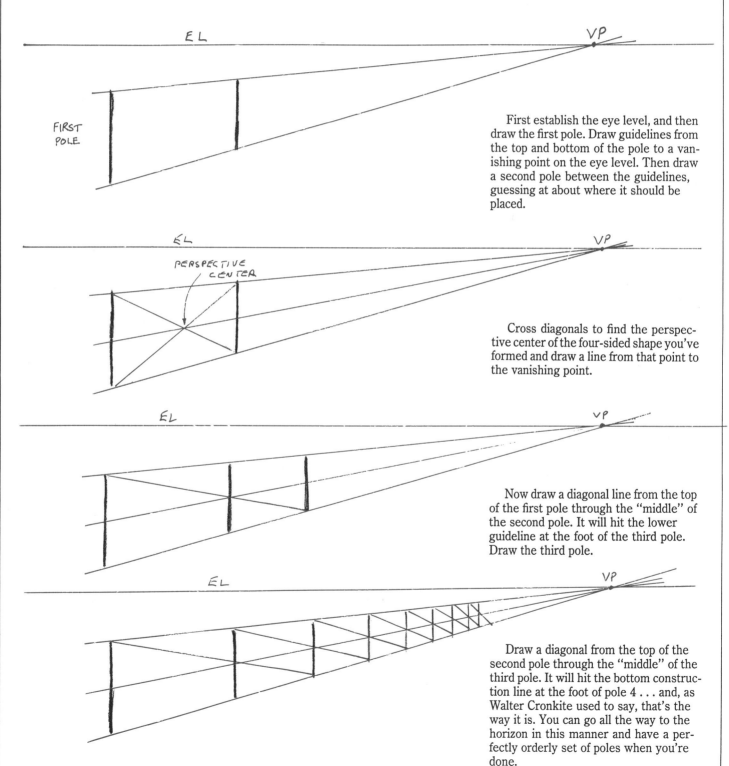

First establish the eye level, and then draw the first pole. Draw guidelines from the top and bottom of the pole to a vanishing point on the eye level. Then draw a second pole between the guidelines, guessing at about where it should be placed.

Cross diagonals to find the perspective center of the four-sided shape you've formed and draw a line from that point to the vanishing point.

Now draw a diagonal line from the top of the first pole through the "middle" of the second pole. It will hit the lower guideline at the foot of the third pole. Draw the third pole.

Draw a diagonal from the top of the second pole through the "middle" of the third pole. It will hit the bottom construction line at the foot of pole 4 . . . and, as Walter Cronkite used to say, that's the way it is. You can go all the way to the horizon in this manner and have a perfectly orderly set of poles when you're done.

Beyond Eyeballing

A Tile Floor

Perhaps more useful would be an example such as a tile floor. Sometimes we include them in interior paintings or still lifes, and if they're not right they'll ruin the painting by making the floor seem to tilt too much or not enough.

Suppose you're drawing a tile floor from a vantage point something like this. You've chosen your viewing position a little right of center (but it could have been at center or left of center).

We'll first draw this floor in one-point linear perspective. The vanishing point will be directly ahead of you—on the eye level, of course.

The reason for choosing one-point is this: when you are so close to a subject (you're standing right on the tile floor, let's say), a second vanishing point would be so far to your right or left that the lines converging toward that VP would have negligible slant. In other words, one-point perspective may be considered two-point perspective with one of the vanishing points out around Mars. For practical purposes, the lines in the tiles running right to left across the scene are parallel to the picture plane. If the floor were large enough—that is, if it stretched far enough away from the viewer—in that case there might be some discernible two-point perspective. An example a little later will illustrate this.

As you can see in the sketch **right**, I've drawn in the lines representing the rows of tiles (they could be floorboards at this point). How do you make them fan out properly? The easiest way, and accurate enough, is to mark off equal widths along the edge where the floor meets the far wall. Then draw lines through those points and the VP.

Next, pick a pair of horizontal lines near to you and sketch them in to define your first tile. These are like the first two poles in the earlier example; once you establish them, everything else becomes pretty mechanical. You may need to experiment a little to get these lines feeling right.

Draw right on this sketch and follow along with me through the rest of the steps.

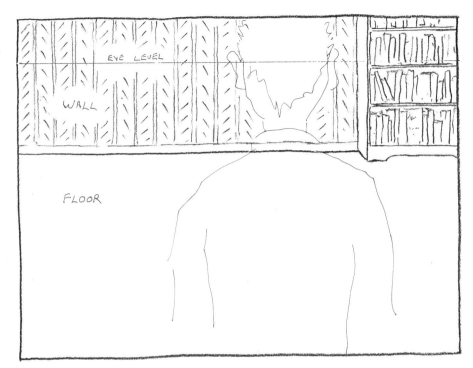

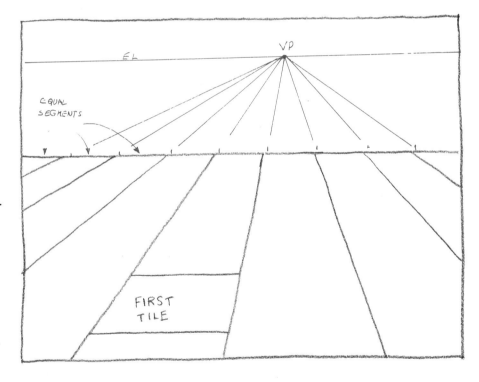

Beyond Eyeballing

Locate the perspective midpoint of the tile by crossing its diagonals, and draw a construction line through it to the VP.

Draw a line from one end of the near tile edge through the "midpoint" of the far tile edge. Where that line hits line *a*, draw horizontal line *b*.

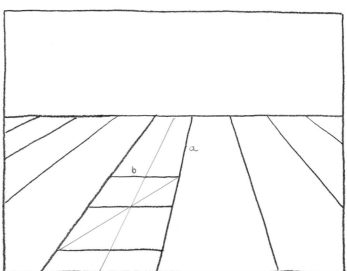

Continue this process until you hit the far wall. If the last tile doesn't come out exactly where the far wall begins, move the wall a little. Nobody will tell.

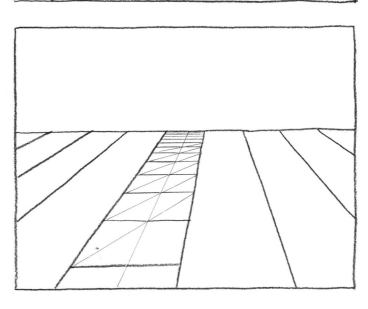

Common Goofs

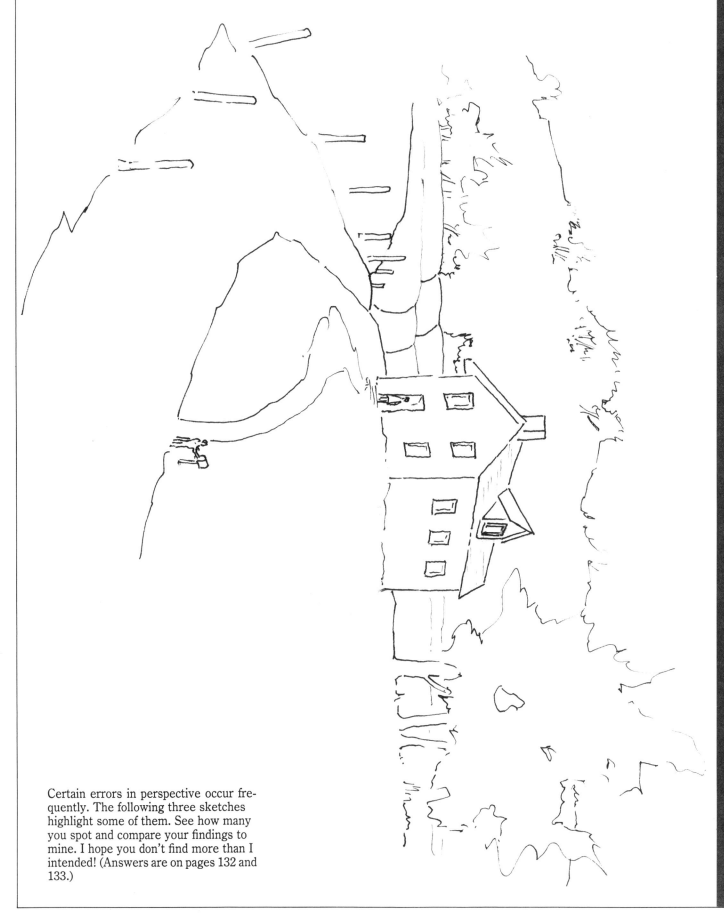

Certain errors in perspective occur frequently. The following three sketches highlight some of them. See how many you spot and compare your findings to mine. I hope you don't find more than I intended! (Answers are on pages 132 and 133.)

Common Goofs

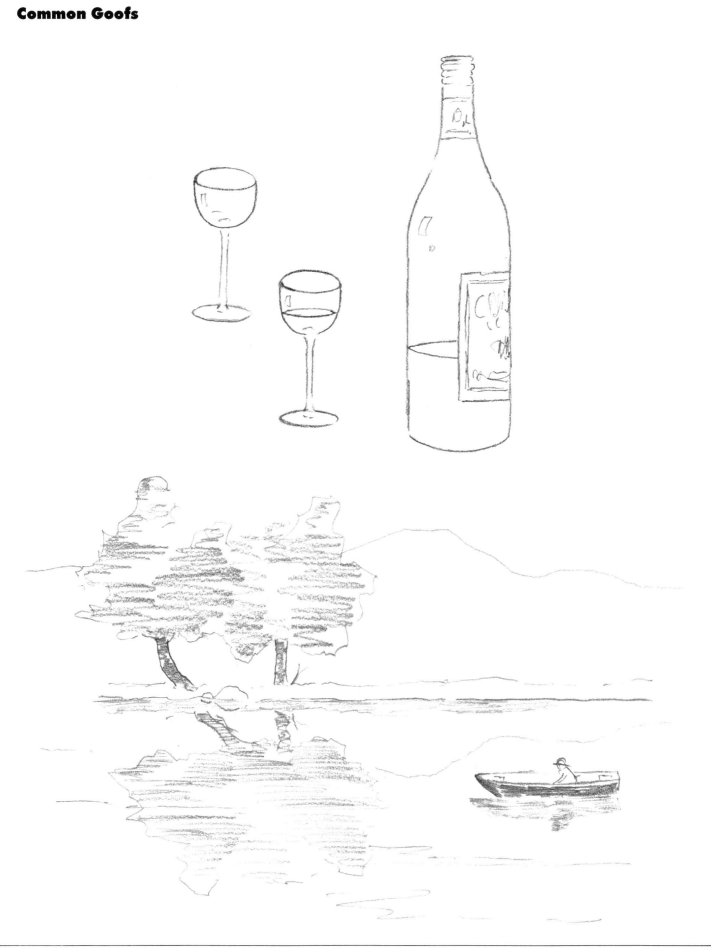

Common Goofs

NO EYE LEVEL
ESTABLISHED —
LINES SUCH AS
① ④ ③ ④
SHOULD ALL CONVERGE
AT A VP ON
EYE LEVEL

FENCE POSTS
DON'T
DIMINISH
IN SIZE
FAST
ENOUGH

ROADWAY GETS
WIDER RATHER
THAN NARROWER
IN DISTANCE

CLOSE-UP EDGES
AND DISTANT EDGES
AND DETAIL
ALL THE SAME
NO SOFTENING IN
DISTANCE

NARROWING
OF PATH
MAKES IT
TOO STEEP

SHINGLE LINES
DON'T SLANT
TO VPR

WINDOWS IN SIDE OF
HOUSE NOT ON SAME
LEVEL AS WINDOWS
IN FRONT OF HOUSE

MUCH
TOO
STEEP

FIGURE AND MAILBOX
OUT OF SCALE WITH
HOUSE

ROOF EDGES
CONVERGING IN
WRONG DIRECTION

132

Common Goofs

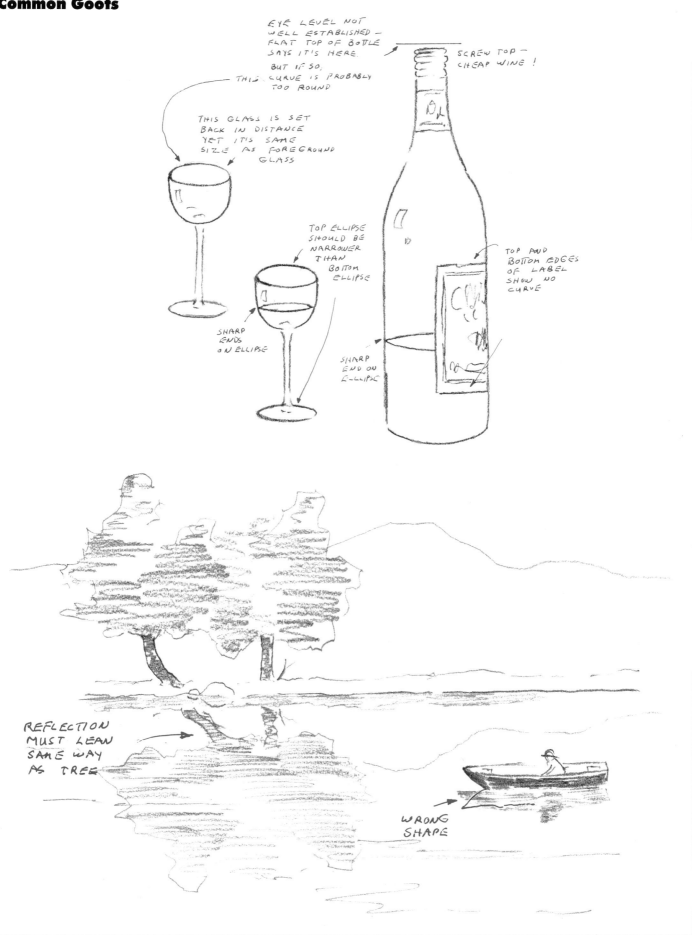

EYE LEVEL NOT WELL ESTABLISHED — FLAT TOP OF BOTTLE SAYS IT'S HERE. BUT IF SO, THIS CURVE IS PROBABLY TOO ROUND

SCREW TOP — CHEAP WINE!

THIS GLASS IS SET BACK IN DISTANCE YET IT'S SAME SIZE AS FOREGROUND GLASS

TOP ELLIPSE SHOULD BE NARROWER THAN BOTTOM ELLIPSE

TOP AND BOTTOM EDGES OF LABEL SHOW NO CURVE

SHARP ENDS ON ELLIPSE

SHARP END ON ELLIPSE

REFLECTION MUST LEAN SAME WAY AS TREE

WRONG SHAPE

Conclusion

Be a little careful in applying the "rules" of perspective. Although the perspective techniques are powerful tools, they have their limitations. What's "right" mathematically or theoretically may not be "right" for your painting.

Earlier, for example, we discussed an accurate way to space objects, such as poles, in such a way that they would recede properly. Although the method discussed will give you an accurate division of spaces, the result might not always be pleasing.

Several scholars have experimented with this very example by presenting people with pictures of receding poles in which perspective (linear perspective, to be more precise) was used rigidly and asking them to choose between those pictures and ones in which certain liberties were taken. In the latter, the receding poles were not made to bunch together quite as rapidly as perspective "rules" would dictate. People chose strongly in favor of the latter.

It's not that linear perspective is wrong—it pretty much duplicates what a good camera would record—it's just that there's no denying certain psychological urges people have for arranging things in certain ways. In the case of the poles, people seemed not to want them to recede quite as precipitously as they really did. I won't pretend to analyze what makes those things happen—I'm only suggesting that you need to know when a tool has done all it can for you and needs to be abandoned in favor of gut feeling.

Another example: linear perspective is only useful within the normal human "cone of vision"—that is, the area you can see ahead, left and right, up and down, without moving your head or eyes. Beyond that space, in peripheral vision, things get pretty distorted. And beyond that space, linear perspective also gets distorted and ineffective.

A good example of a failing of linear perspective is in painting a very long mural, or perhaps an ornamented frieze along the top edge of a building. It's quite impossible to view such long scenes without actually moving yourself physically and strolling along the length of the picture, or standing so far back that you can see everything at once but can discern little of the picture's detail. What many artists have resorted to in such situations is to break the picture into a series of scenes, each with its own vanishing points, rather than attempt one long scene with a single set of vanishing points.

Despite such limitations, perspective works well for the vast majority of the scenes most of us draw and paint.

Now that you've waded through this book and assimilated everything, let me plead one final time for moderation in the application of what we've covered. Perspective is a tool for helping to gain a sense of depth in a drawing or painting, nothing more. Perspective is not an end in itself. Too rigidly applied, the techniques of perspective could smother an otherwise expressive painting. Don't let them tie you down.

INDEX

Improve your skills, learn a new technique, with these additional books from North Light

Business of Art

Artist's Friendly Legal Guide, by Floyd Conner, Peter Karlan, Jean Perwin & David M. Spatt $18.95 (paper)

Artist's Market: Where & How to Sell Your Art (Annual Directory) $21.95 (cloth)

Handbook of Pricing & Ethical Guidelines, 7th edition, by The Graphic Artist's Guild $22.95 (paper)

North Light Dictionary of Art Terms, by Margy Lee Elspass $12.95 (paper)

Art & Activity Books For Kids

Draw!, by Kim Solga $11.95
Paint!, by Kim Solga $11.95
Make Clothes Fun!, by Kim Solga $11.95
Make Prints!, by Kim Solga $11.95
Make Gifts!, by Kim Solga $11.95
Make Sculptures!, by Kim Solga $11.95

Watercolor

Basic Watercolor Techniques, edited by Greg Albert & Rachel Wolf $14.95 (paper)

Buildings in Watercolor, by Richard S. Taylor $24.95 (paper)

Chinese Watercolor Painting: The Four Seasons, by Leslie Tseng-Tseng Yu $24.95 (paper)

The Complete Watercolor Book, by Wendon Blake $29.95 (cloth)

Fill Your Watercolors with Light and Color, by Roland Roycraft $28.95 (cloth)

Flower Painting, by Paul Riley $27.95 (cloth)

How to Make Watercolor Work for You, by Frank Nofer $27.95 (cloth)

Jan Kunz Watercolor Techniques Workbook 1: Painting the Still Life, by Jan Kunz $12.95 (paper)

Jan Kunz Watercolor Techniques Workbook 2: Painting Children's Portraits, by Jan Kunz $12.95 (paper)

The New Spirit of Watercolor, by Mike Ward $21.95 (paper)

Painting Nature's Details in Watercolor, by Cathy Johnson $21.95 (paper)

Painting Watercolor Portraits That Glow, by Jan Kunz $27.95 (cloth)

Splash I, edited by Greg Albert & Rachel Wolf $29.95

Starting with Watercolor, by Rowland Hilder $12.50 (cloth)

Tony Couch Watercolor Techniques, by Tony Couch $14.95 (paper)

Watercolor Impressionists, edited by Ron Ranson $45.00 (cloth)

Watercolor Painter's Solution Book, by Angela Gair $19.95 (paper)

Watercolor Painter's Pocket Palette, edited by Moira Clinch $15.95 (cloth)

Watercolor: Painting Smart, by Al Stine $27.95 (cloth)

Watercolor Workbook: Zoltan Szabo Paints Landscapes, by Zoltan Szabo $13.95 (paper)

Watercolor Workbook: Zoltan Szabo Paints Nature, by Zoltan Szabo $13.95 (paper)

Watercolor Workbook, by Bud Biggs & Lois Marshall $21.95 (paper)

Watercolor: You Can Do It!, by Tony Couch $27.95 (cloth)

Webb on Watercolor, by Frank Webb $29.95 (cloth)

The Wilcox Guide to the Best Watercolor Paints, by Michael Wilcox $24.95 (paper)

Mixed Media

The Art of Scratchboard, by Cecile Curtis $23.95 (cloth)

The Artist's Complete Health & Safety Guide, by Monona Rossol $16.95 (paper)

The Artist's Guide to Using Color, by Wendon Blake $27.95 (cloth)

Basic Drawing Techniques, edited by Greg Albert & Rachel Wolf $14.95 (paper)

Blue and Yellow Don't Make Green, by Michael Wilcox $24.95 (cloth)

Bodyworks: A Visual Guide to Drawing the Figure, by Marbury Hill Brown $24.95 (cloth)

Business & Legal Forms for Fine Artists, by Tad Crawford $4.95 (paper)

Calligraphy Workbooks (2-4) $3.95 each

Capturing Light & Color with Pastel, by Doug Dawson $27.95 (cloth)

Colored Pencil Drawing Techniques, by Iain Hutton-Jamieson $24.95 (cloth)

The Complete Acrylic Painting Book, by Wendon Blake $29.95 (cloth)

The Complete Book of Silk Painting, by Diane Tuckman & Jan Janas $24.95 (cloth)

The Complete Colored Pencil Book, by Benard Poulin $27.95 (cloth)

The Complete Guide to Screenprinting, by Brad Faine $24.95 (cloth)

Complete Guide to Fashion Illustration, by Colin Barnes $11.95 (cloth)

The Creative Artist, by Nita Leland $12.95 (cloth)

Creative Basketmaking, by Lois Walpole $12.95 (cloth)

Creative Painting with Pastel, by Carole Katchen $27.95 (cloth)

Decorative Painting for Children's Rooms, by Rosie Fisher $10.50 (cloth)

The Dough Book, by Toni Bergli Joner $15.95 (cloth)

Drawing & Painting Animals, by Cecile Curtis $26.95 (cloth)

Exploring Color, by Nita Leland $24.95 (paper)

Festive Folding, by Paul Jackson $17.95 (cloth)

The Figure, edited by Walt Reed $16.95 (paper)

Fine Artist's Guide to Showing & Selling Your Work, by Sally Price Davis $17.95 (paper)

Getting Started in Drawing, by Wendon Blake $24.95

The Half Hour Painter, by Alwyn Crawshaw $19.95 (paper)

Handtinting Photographs, by Martin and Colbeck $28.95 (cloth)

How to Paint Living Portraits, by Roberta Carter Clark $27.95 (cloth)

How to Succeed As An Artist In Your Hometown, by Stewart P. Biehl $24.95 (paper)

Introduction to Batik, by Griffin & Holmes $9.95 (paper)

Keys to Drawing, by Bert Dodson $21.95 (paper)

Light: How to See It, How to Paint It, by Lucy Willis $19.95 (paper)

Make Your Own Picture Frames, by Jenny Rodwell $12.95 (paper)

Master Strokes, by Jennifer Bennell $27.95 (cloth)

The North Light Handbook of Artist's Materials, by Ian Hebblewhite $4.95 (cloth)

The North Light Illustrated Book of Painting Techniques, by Elizabeth Tate $27.95 (cloth)

Oil Painting: Develop Your Natural Ability, by Charles Sovek $27.95

Painting Floral Still Lifes, by Joyce Pike $19.95 (paper)

Painting Flowers with Joyce Pike, by Joyce Pike $27.95 (cloth)

Painting Landscapes in Oils, by Mary Anna Goetz $27.95 (cloth)

Painting More Than the Eye Can See, by Robert Wade $29.95 (cloth)

Painting Seascapes in Sharp Focus, by Lin Seslar $22.95 (paper)

Painting the Beauty of Flowers with Oils, by Pat Moran $27.95 (cloth)

Painting with Acrylics, by Jenny Rodwell $19.95 (paper)

Pastel Painting Techniques, by Guy Roddon $19.95 (paper)

The Pencil, by Paul Calle $19.95 (paper)

Perspective Without Pain, by Phil Metzger $19.95

Putting People in Your Paintings, by J. Everett Draper $19.95 (paper)

Realistic Figure Drawing, by Joseph Sheppard $19.95 (paper)

Tonal Values: How to See Them, How to Paint Them, by Angela Gair $19.95 (paper)

To order directly from the publisher, include $3.00 postage and handling for one book, $1.00 for each additional book. Allow 30 days for delivery.
North Light Books
1507 Dana Avenue, Cincinnati, Ohio 45207
Credit card orders
Call TOLL-FREE
1-800-289-0963
Prices subject to change without notice.